WHY YOU LIKE THIS PHOTO

An Hachette UK Company
www.hachette.co.uk

First published in Great Britain in 2018 by
ILEX, an imprint of Octopus Publishing Group Ltd

Octopus Publishing Group
Carmelite House
50 Victoria Embankment
London, EC4Y 0DZ
www.octopusbooks.co.uk
www.octopusbooksusa.com

Distributed in the US by Hachette Book Group
1290 Avenue of the Americas, 4th & 5th Floors
New York, NY 10104

Distributed in Canada by Candian Manda Group
664 Annette St., Toronto, Ontario, Canada, M65 2C8

Publisher, Photography: Adam Juniper
Managing Editor: Frank Gallaugher
Publishing Assistant: Stephanie Hetherington
Art Director: Julie Weir
Design: JC Lanaway
Picture Research: Giulia Hetherington
Senior Production Manager: Peter Hunt

ISBN 978-1-78157-374-7

A CIP catalogue record for this book
is available from the British Library

Printed and bound in China

10 9 8 7 6 5 4 3 2 1

WHY YOU LIKE THIS PHOTO

THE SCIENCE OF PERCEPTION

BRIAN DILG

ilex

CONTENTS

3. HOW WE THINK
DECODING PHOTOGRAPHS

4. CONCLUSIONS

INTRODUCTION

When I was a college undergrad, we were given an assignment for our art history class: write a paper on any painting we choose. I found this portrait (opposite) of a pretty French girl, and sat down to study it.

At the same time, I was also taking drawing classes. The principles of observation had been explained to me, but I was impatient. I did more drawing than looking, so unsurprisingly, my drawings were inaccurate. Because of my own shortcomings in this area, I was especially curious about how the painter achieved such lifelike results.

Two things happened that year that I've never forgotten. After studying the painting for about 90 minutes, I left, having seen all I could absorb. It was a beautiful day, and I walked along a familiar route, but that afternoon, something very strange happened. Everywhere I looked, I seemed to be seeing colors, shapes, and movement for the first time. It was as if a switch had flipped in my brain. Everything looked utterly amazing—brilliant, vivid, sharp, hyper-real. It was staggering.

Around that same time, I was struggling in a drawing class, as usual. The instructor had set up a still life, and I could not get the proportions right.

My teacher appeared. He tied my conté crayon to the end of a branch about a foot long. "Draw," he commanded. I tried—and instantly complained that it was impossible to control the crayon. "Exactly," he said, and walked away. Making accurate marks took my entire concentration.

NOBODY SEES A FLOWER—REALLY—IT IS SO SMALL IT TAKES TIME—WE HAVEN'T TIME—AND TO SEE TAKES TIME, LIKE TO HAVE A FRIEND TAKES TIME

WERNER HEISENBERG

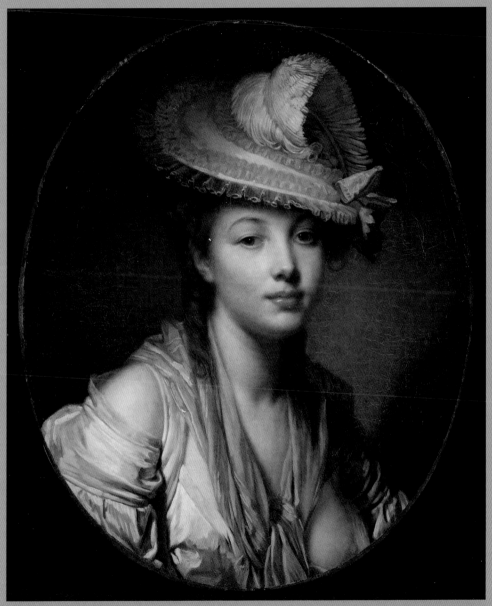

The White Hat, Jean-Baptiste Greuze, c. 1780.

TO LOOK IS ALSO TO OVERLOOK—PARTICULARLY WHEN IT COMES TO WHAT WE THINK WE ALREADY KNOW. THERE'S JUST TOO MUCH TO SEE TO TRULY SEE IT ALL

When the session ended, we strolled around inspecting each others' drawings. I noticed everyone was gathering around one particular easel—mine. I braced myself to be Mr. What-Not-To-Do. A long silence passed. Then someone said: "How did you do that?"

It was dead accurate.

I was dumbounded. I'd been too busy drawing to see what I'd done. Why did the act of crippling me, of making it harder to draw, produce the first truly excellent drawing I'd ever made?

These stories speak to the thesis of this book: there is a huge gap between what we see and what we think we see. Our evolution is oriented towards survival. Survival depends on efficiency. Efficiency means being able to process what's happening at incredible speed.

Every experience adds to a vast catalog of behavior and consequences: tigers have stripes, lurk in shadows, and can smell us if we're upwind. Drivers don't necessarily obey the rules of the road, so don't assume they'll stop if you walk into the street.

Our minds are contantly updating this unique mental model of the world. We can only attend to a narrow bandwidth of experience at once. We manage the overload largely by comparing experience to expectations. So to look is also to overlook—particularly when it comes to what we think we already know. There's just too much to see to truly see it all.

The truth is, the very expertise that helps us survive sets us up to be shocked when a photograph shows us how different things are from our perceptions. Perhaps you believe you see things more clearly than other people.

This book will disabuse you of that illusion.

By doing so, I hope to transform your world, whether you're a photographer or just love photos.

Anton Mauve's 1885 pencil *Portrait of Pieter Frederick van Os* is a terrific example both of a brilliantly seen and accurately rendered depiction. But, it's also a subjective representation of a real subject, which parallels the way our own seeing is a mental construction, not a simple optical record.

HOW WE SEE
HUMANS vs. CAMERAS

LOOKING vs. SEEING
THE PROBLEM WITH EXPERIENCE

Remember the story of my breakthrough drawing experience? So how did crippling my control of the crayon enable me to make my first truly accurate drawing? The suddenness of the change suggests that it was not a matter of talent or divine intervention, but that I already had the ability to see and draw accurately. The problem was experience itself. (Although impatience wasn't helping either.)

In front of me were tin cans, string, and boxes. I wasn't yet old or worldly, but I knew how these objects looked: tins cans are cylindrical and shiny. When stretched tight, string is straight. Boxes are rectangular. So what is there to see here?!

The thought process I've written about here very much describes the part of your brain that dominates your waking hours. It has no patience for subtle color or tonal and spatial relationships.

Thank goodness that part is dominant. If you notice something falling from the sky, you want the part of your brain that can calculate its path, velocity, and where to go to escape to take over, not the part that admires how the sunlight sparkles on it.

When my wise teacher made it so difficult for me to control my drawing, the part of me that kept drawing simplistic symbols based on past experience couldn't continue. I physically could not make those marks. All I could do was look, draw extremely slowly, and compare my drawing to what I saw.

The problem with my past experience was that in our everyday, survival-oriented life, we simply don't have the time or the need to study subtleties of shape, light, and color. Therefore, I knew nothing about how this particular scene actually looked. I could only learn that by taking the time to see it as it really was.

WHAT WE OBSERVE IS NOT NATURE ITSELF,
BUT NATURE EXPOSED TO OUR METHOD OF QUESTIONING

WERNER HEISENBERG

Photographers exploit what viewers expect to see to surprise them with images that defy those expectations. In order to do so, they have to develop their own ability to see more than the utilitarian value of a scene. This is especially difficult given that the greater our experience, the more familiar the world looks, and the less attention we give it.

MEETING THE MENTAL MODEL

Experience builds a mental model of the world. New information is compared with this model to identify things and predict the future. When something defies expectations, your brain notices, and can get very confused. This example will give you an opportunity to explore just how insistent your mental model is that the world should conform to expectations— and how it utterly misperceives a world that doesn't conform.

Having such a sophisticated, thorough mental model of the world keeps us alive and allows us to do pretty much all of the truly remarkable things that human beings can do: phenomenal agility in sports, for example. But when it comes to making art (or coming up with new ideas), experience can also get in the way. If we cannot bypass what we expect to see, there is little chance that we will be able to actually see. We'll filter it right out.

You'll find it impossible for your eyes to rest comfortably on this strange face. They constantly jump around, unable to reconcile what clearly ought to be a face with what you're actually seeing. The features of faces are acutely catalogued in our memory, but this one breaks the rules. It's impossible for your eyes to rest comfortably on either set of eyes or either mouth and just see it as a copy. Your brain badly wants the face to conform to its pre-existing expectations.

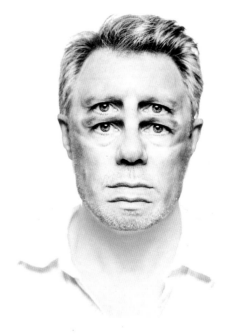

Skeptical? Try doing internet video searches for "selective attention," and "change blindness," then watch your mind lead you astray.

We're constantly faced with so much sensory input that we can only process a tiny fraction of it. If I can convince you that you see far, far less than you think you do, your entire experience can be transformed. A rich, overlooked world may appear.

Making photographs is like tuning your attention to frequencies that you didn't know existed, and finding out that the radio has an unlimited number of channels. If you practice seeing and orchestrating gestures, color relationships, shapes, motifs, light, and shadow, you will broaden not just your perception, but your ability to construct a story for an audience. The same goes for your experience as a viewer.

Photographers practice in order to develop perceptual muscles until they're able to previsualize even a complex picture in a split second. As I was crossing the street, I literally had a second to see this scene and make a photograph. Many elements formed the idea of the photo (try counting how many sets of stripes you see, for example). After decades of practice, this all happens so quickly that I am often surprised when I look at the photo later—although I still take plenty of uninteresting photos that end up in the trash too!

ANGLE OF VIEW

HUMAN ANGLE OF VIEW

What you see with your eyes is a composite view—two images combined to give you roughly a 180° field of view. Our vision is not as wide as that of a fish, but it's enough to see tigers hiding in bushes.

If you look straight ahead with your hands out at your sides, you can see them, but they're vague. Human peripheral vision is optimized to detect movement—it's more important to determine whether something deserves your attention than to know exactly what it looks like.

Stare at the "X" in the middle of the letters below. Without moving your eyes, how many letters can you read confidently?

Most people report that they can read two or three letters on either side of the "X." In fact, you can only see clearly in about 1–2% of your 180° field of view. While the back of the retina is peppered with photoreceptors, most are concentrated in a small area called the fovea. Only when we look straight at something do we see sharp detail.

What we see is a composite derived from two images seen from slightly different positions. These images from each eye overlap and are combined in the brain, creating a stereoscopic image with a combined angle of view of around 180 degrees.

A W R E B N P X Q Z T O S L M

CAMERA ANGLE OF VIEW

With a few exceptions, cameras have one lens. They "see" more-or-less equally sharply across their entire field of view, which is considerably narrower than our field of view when peripheral vision is taken into account.

Only the fisheye lens matches our two-eyed, 180° field of view. However, fisheye images are nothing like the human viewing experience.

Also, we can't zoom! While we must physically move our feet, most cameras provide a range of focal lengths. Wide-angle lenses typically see 75–84°, but a 300mm telephoto lens has only an 8° angle of view. As focal length gets longer, the angle of view narrows in on the subject, which is magnified.

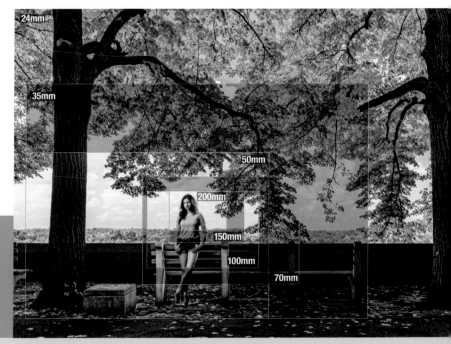

Here, I've overlaid graphics to show the approximate field of view that each common focal length would capture.

DYNAMIC VIEW vs. STATIC FRAME

SACCADES

Given that we can only sharply see a 1–2% view, how do we get a clear look at our surroundings? Unlike a camera, we don't look once; rather, we look around. Our eyes dart in rapid movements called saccades.

Saccades typically happen several times per second. Our eyes jump to a new spot where our attention lingers, but even then, our gaze continues to drift and make smaller movements called micro-saccades.

We have a dynamic view, not a camera's fixed perspective. This exploration is not limited to eye movements—it's accompanied by head movement and physical mobility too, and we never stop looking. Our ability to see is in fact so dependent on motion that if we force ourselves to hold our gaze perfectly still, the image actually fades.

We never see an entire scene at once. Our gaze, as well as our conscious attention, is constantly changing, and we never stop updating our view. Cameras, on the other hand, "look" once and record the entire scene in a single, static frame.

ATTENTION & PERCEPTION

At a cocktail party, we can't hear every conversation simultaneously; we filter. Vision is similar. While we believe that we see an entire scene at once, close to the way a camera "sees," our impression is actually a collage of quick snapshots. It's a product of both a shifting gaze and selective attention. Yet it feels as if we effortlessly see the entire scene.

Neurologists have demonstrated that in order to see anything, we have to suppress everything else. Effectively, we have tunnel vision, but we have no awareness of just how much we miss.

I have heard a frequent complaint: "Why won't my camera see how I see?" But it's impossible for a camera to record things the way we see them, because the view we think we see simply doesn't exist!

The spotlight of our conscious attention is incredibly narrow. While it's true that we perceive far less than we think we do, photographs can show us much of what we've missed, despite their limitations.

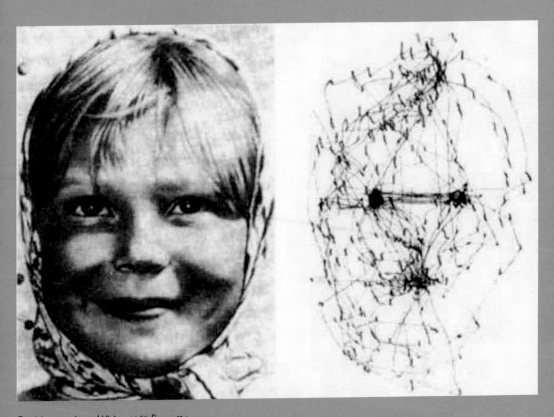

Eye Movements and Vision, 1967, figure 114.

Above is a classic study by Alfred Yarbus showing human eye
movements over a face, known as saccades. The image is a
recording of the eye movements of a viewer as they looks at this
human face. It's easy to see where we linger: eyes, nose, mouth.

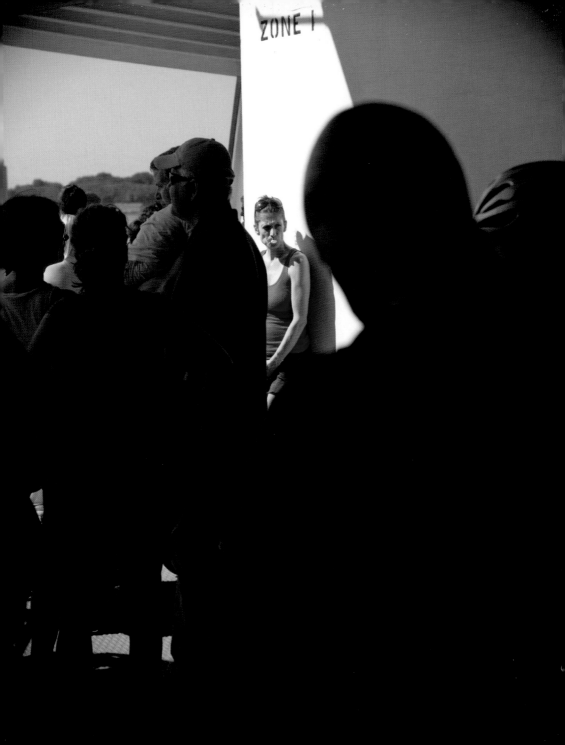

PHOTOGRAPHIC FRAME

There is a significant difference between the way we look at the world and what cameras show us: we have total control over where we look. A photograph only presents what the photographer shows us. The ability to look around is taken away from us, because to take a picture is to put a finite frame around a slice of the world. The edges of that time span and physical frame limit what we are allowed to see. Of course, our eyes are free to roam within the photo, but we can't see beyond its edges.

The fixed frame brings with it a set of challenges for the photographer. They must decide what to include and what to omit. Plus,

there's the big basic challenge of photography: composing three-dimensional shapes within a flattened picture plane in an organized, effective way. Since no clear frame exists in our own visual system, I don't think this comes naturally. It seems to be a skill that can only be acquired by long study and practice.

We like photos in part because of what they don't show us. They simplify the world and allow us to experience a manageable slice of life. The frame can also be compared to the spotlight of conscious attention, singling out a theme and subject from a never-ending, overwhelming stream of visual input.

The frame works in concert with other aspects to direct our attention. In this image, I used the shadowy figures to frame my main subject, which also grabs your attention because of the brightness, the red color, the text on the wall, her more-or-less centered position, and possibly because of the subtle moment of tension created by the bubble gum.

TO TAKE A PICTURE IS TO PUT A FINITE FRAME
AROUND A SLICE OF THE WORLD

FOREGROUND-BACKGROUND RELATIONSHIPS

A photograph is a two-dimensional rendering of the three-dimensional world. It flattens perspective and draws attention to the spatial relationships between objects. While the spotlight effect of our conscious attention tends to blind us to anything other than what we're concentrating on, photographs freeze the chaotic world, inviting us to compare and infer relationships between elements in the frame.

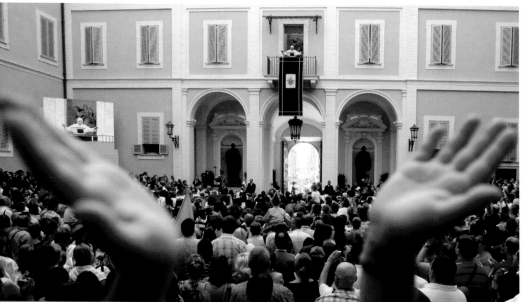

Pope Benedict XVI at Castel Gandolfo, 2011

Photographer Pier Paolo Cito demonstrates foreground-background relationships well by juxtaposing a parishioner's upraised hands against the background, thereby creating depth in the image.

In this image, we seem to be looking down on a surface, perhaps a swimming pool, but close study reveals otherwise. I shot this photo of a building with fabric covering one whole side, looking up from the ground at a steep angle. I rendered the sky black to make the vantage point less obvious.

VANTAGE POINT, EXPECTATION, & SURPRISE

These two images were designed to mislead you; they're at odds with our mental model of how the world is supposed to look. They're meant to make your mind think one thing at first glance, entice you to examine closer, and then surprise you.

Both of these images cause a little a jolt of surprise when the true vantage point is realized. And even after we know a photo's secret, it's near impossible not to experience that surprise afresh every time we look at the image.

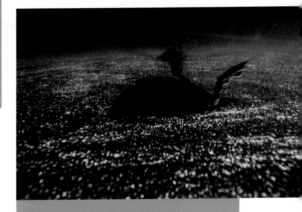

This photo is of a duck swimming normally, not diving. It was shot from underwater and then flipped upside down.

FOCAL LENGTH & MAGNIFICATION

While the angle of view of a normal focal-length lens differs from our eyes' combined 180°, its magnification (how large objects appear to be at a given distance) is comparable. Today's cameras offer lenses from wide-angle to extreme telephoto.

An obvious difference between a wide-angle lens and a telephoto lens is magnification. The wider the lens, the farther away objects appear. A telephoto lens makes objects seem closer to the camera. Other differences, such as compression and apparent plane of focus, also characterize wide-angle vs. telephoto, but for now we'll focus on magnification.

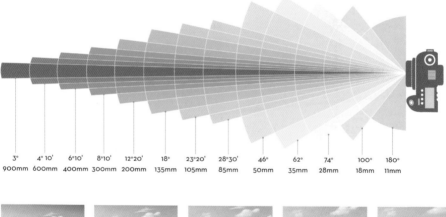

| 3° | 4° 10' | 6°10' | 8°10' | 12°20' | 18° | 23°20' | 28°30' | 46° | 62° | 74° | 100° | 180° |
| 900mm | 600mm | 400mm | 300mm | 200mm | 135mm | 105mm | 85mm | 50mm | 35mm | 28mm | 18mm | 11mm |

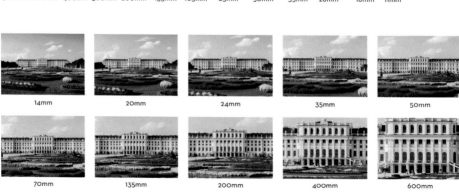

14mm 20mm 24mm 35mm 50mm

70mm 135mm 200mm 400mm 600mm

ZOOM LENSES

A zoom lens offers variable focal length while sacrificing some sharpness and light-gathering ability. Most people zoom as though it's no different from changing their position, but they do not produce the same result.

A subject can be made larger by using a longer focal length—"zooming in"—or by moving the camera closer. However, longer focal lengths compress objects along the Z axis (i.e, subject-to-camera distance), making them appear closer together. Moving closer means shifting the focal point closer to the sensor. Both reduce depth of field, but the perspective (magnification and angle of view) is not the same. These visual cues also convey a sense of the distance between camera and subject.

SPECIAL LENS FEATURES

All lenses have a near focal limit—the shortest distance a lens can be from a subject while maintaining focus. Some lenses offer macro capability, allowing them to focus while extremely close to a subject, achieving extraordinary magnification. Longer lenses typically can't focus as close as shorter lenses.

However, the near focal limit of any lens can be reduced with a close-up filter on the front of the lens, or by inserting an extension tube between the lens and the camera body, thus adding macro capability.

60mm Macro lens

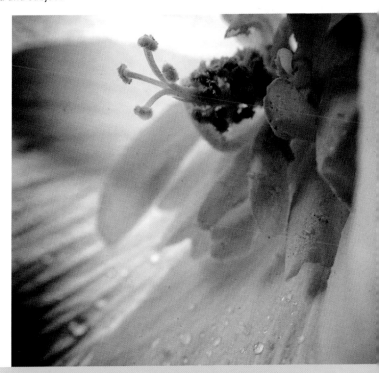

Extension tube

FOCUS & SHARPNESS

THE HUMAN FOCUS SYSTEM

Try looking at something without focusing on it. Good luck. Your eyes have a pesky habit of trying to bring anything you look at directly into sharp focus. Wherever we center our gaze, our eyes focus the image on our fovea. Outside of our 1–2° foveal view, our peripheral vision conveys a less clear image. Anything closer or farther becomes increasingly unclear for two reasons:

DEPTH OF FIELD

Close one eye. Hold one finger a few centimeters from your nose. Focus on the distant background. You'll notice a blurred image of your finger, as long as you don't look directly at it. (This is similar to any camera lens.) Images are sharpest at the eyes' focal point—the distance at which we've concentrated rays of light onto our retinas—and get increasingly blurry behind or in front of that point.

STEREOSCOPIC VIEW

Things also look less clear behind or in front of our focal point because our two eyes see two different images; and those images are seamlessly combined only at the focal point.

Move your finger far enough from your nose to focus on it, and open both eyes. Now focus on the distant background, and you'll see two fingers! Those are two discrete images produced by your eyes, each at slightly different positions in three-dimensional space.

Now close one eye at a time. Your finger will "jump" back and forth as you see the view from each eye independently. Shift your focus to the background, and the jump will be bigger, as the images are even farther out of alignment.

Normally, we notice none of this. Our three-dimensional view is flawless, and we never see an entire scene at once. We rapidly shift our gaze and assemble many perfectly focused images into a sense of the entire scene.

YOUR EYES HAVE A PESKY HABIT OF TRYING TO BRING ANYTHING
YOU LOOK AT DIRECTLY INTO SHARP FOCUS

Close one eye at a time and you'll see your finger "jump" back and forth as you see the view from each eye independently. Shift your focus to the background, and the jump will be bigger, as the images are even farther out of alignment.

FOCUS & CAMERAS

Cameras use a single lens to project a single image onto a digital sensor or film. (3D systems capture two separate images through two different lenses.) A camera must capture an entire scene in a single image from one perspective. It's static, not dynamic like the roving human perceptual system.

Furthermore, the photographer chooses the focal point. This introduces an experience that is almost entirely foreign to us as viewers: we've lost control over what is in focus.

Conventionally, the focal plane is parallel to the image sensor or film. However, some cameras allow that focal plane to be skewed or tilted in three-dimensional space so it's no longer parallel to the recording medium.

This was a standard feature when large format view cameras were the only game in town. The common digital SLR allows us to do this only with a specialty perspective control or tilt/shift lens.

If you're taking a picture of a tall building from the ground nearby, the camera is farther from the top of the building than it is from the bottom. The building will look as though its sides are converging at the top.

This can be corrected by shifting the lens plane up to "see" a higher part of the building while keeping the digital sensor or film parallel to the building itself.

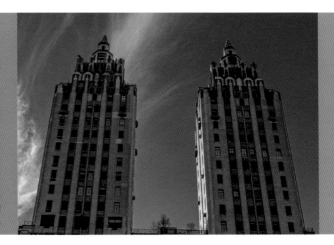

This image (close right) of the two buildings was shot from ground level without the benefit of a tilt/shift (perspective-correction) lens. To overcome the distortion caused by the difference in distance between the camera and the top vs. the bottom of the building, I stretched the photo to show the buildings as they actually are. Of course, a digital transformation will not produce the same quality as an optical correction done in-camera, and you'll lose some of the image at the corners once it's recropped to a standard aspect ratio.

When the objects that need to be sharply in focus are not parallel to the sensor plane, greater depth of field (see overleaf) is required, as shown in the near-right illustration. But there are limits to how much depth of field can be obtained by using a small aperture ("stopping down").

A perspective control or tilt/shift lens (a lens that can be tilted relative to the camera) allows the focal plane to be skewed so it can be made parallel to objects you wish to have sharply focused, thus minimizing depth of field requirements, as shown in the far-right illustration.

LENSES TILTED TO LEFT OR RIGHT, FROM VERTICAL VIEWPOINT

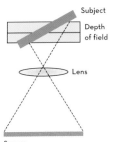

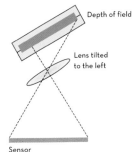

A camera doesn't just allow us to control what is and isn't in focus; multiple images can also be aligned and assembled in post-production, either extending the range of what's sharply in focus (focus stacking) or selectively revealing sharp or blurred areas for creative reasons.

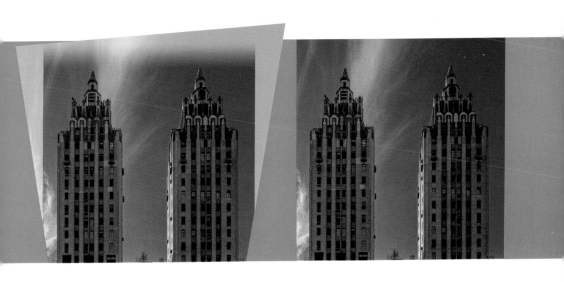

DEPTH OF FIELD

Sharpness falls off gradually on either side of an image's focal plane. The range of acceptable sharpness is called depth of field, which is not really a part of the human viewing experience. Wherever we look, we focus, and what we don't look straight at is only vaguely seen by non-foveal photoreceptors. Also, the images from our eyes are only synchronized at the focal plane; on either side of that is a messy double image instead of a pleasing blur, like we see in photographs.

Photographers can use a small aperture to achieve deep focus, as in this portrait shot at *f*/22. Or, a subject can be isolated, like in the night portrait shown opposite.

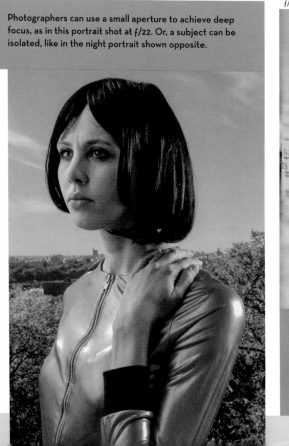

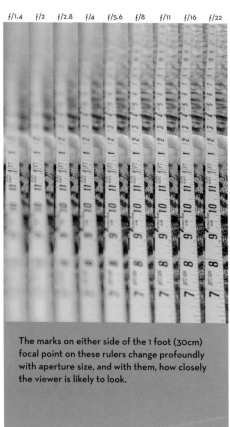

f/1.4 *f*/2 *f*/2.8 *f*/4 *f*/5.6 *f*/8 *f*/11 *f*/16 *f*/22

The marks on either side of the 1 foot (30cm) focal point on these rulers change profoundly with aperture size, and with them, how closely the viewer is likely to look.

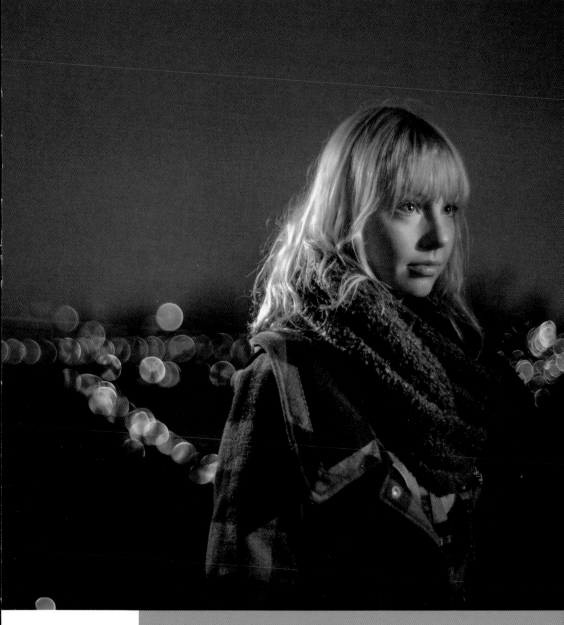

This night portrait was shot at f/1.4. The large aperture minimized the depth of field, making the subject stand out against the blurred background.

DEPTH OF FIELD & FORMAT SIZE

The smaller a camera sensor, the greater the depth of field. There are seemingly endless sensor sizes available, from large format (4 × 5 inches or about 10 × 12.7cm) down to the tiniest cell phone camera sensors (averaging around 1/3 inch or about 8.5mm). This makes photography much easier, as focus is almost a non-issue.

Shallow depth of field underscores three dimensionality, while deep focus presents a more two-dimensional image, flattening space.

Each has its creative application. Our eyes see the world more or less in deep focus, so our lack of familiarity with selective focus makes it a particularly striking feature of photography.

Unfortunately, the dominance of small digital formats has homogenized the use of depth of field. I hope when larger sensors become affordable, that we'll see some diversity return, but modern lenses make that very difficult.

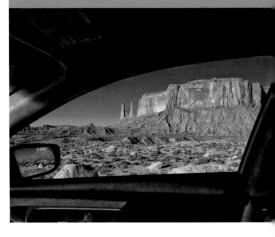

This image of Monument Valley made with a cell phone camera renders everything sharp. This more closely correlates to what we think we see with our eyes.

Photographers can exploit the unique ability of larger formats to capture a contrast of extraordinary sharpness and extreme blur through exceptionally shallow depth of field, as in this image made on an 8 x 10 inch (20 x 25cm) film format at an aperture of f/2.5. Depth of field is almost absurdly shallow here.

OUR EYES SEE THE WORLD MORE OR LESS IN DEEP FOCUS

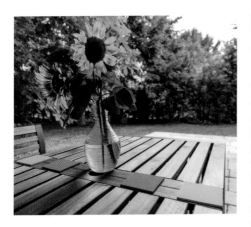

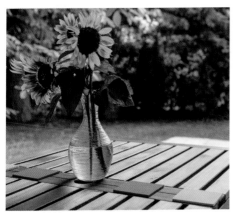

DEPTH OF FIELD & FOCAL LENGTH

Depth of field is also profoundly affected by focal length. Wide-angle lenses have the greatest depth of field; telephoto lenses have the least, as you can see in these sunflower images. Unfortunately, today's lenses have made it all but impossible for photographers to calculate depth of field. An autofocus lens has a motorized focus ring that spins until contrast is maximized. The shorter the focus ring, the faster the motor can focus; and fast focus sells lenses!

The unhappy consequences of shortening the focus ring are twofold: first, we can't accurately focus manually because of the minute precision; secondly, the depth of field scale that used to be on lens barrels is gone. This scale allowed photographers to determine how deep depth of field would be at a given aperture and focus setting.

Given how short the focus rings are now, there simply isn't room. The engineering goals of precise manual focus and fast autofocus are utterly opposed. Autofocus sells cameras, and manufacturers sell a lot more cameras to people who have never heard of depth of field than to pros. This has quietly had a huge effect on photography and photographers who have grown up thinking of focus as a point instead of a range.

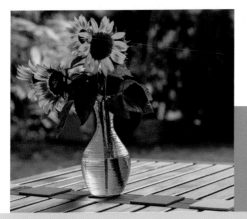

Wider focal lengths produce more depth of field. The top image is the widest of the three at 25mm, then you can see the apparent focus becomes shallower as the focal length gets longer, from 50mm and then to 105mm.

THE EXPERTS SPEAK

DR. MARTIN ROLFS, VISION SPECIALIST

Dr. Martin Rolfs is a vision specialist at the Bernstein Center and Department of Psychology at Humboldt University in Berlin. He is an expert in what gets our attention, how we direct both our gaze and our mental focus, and in particular, how eye, head, and body movements affect perception.

One of the first things I learned in our conversation was that all perception happens at a cost:

"When you're looking hard in an effort to see something specific, you suppress recognition of alternatives, like looking for a yellow cab and not seeing an Uber car. Letting your mind drift instead of focusing on a particular aspect or internal thoughts, you'll be more open to external triggers, or other triggers inside you that might become relevant. These alternatives have a bigger chance of getting selected by accident than when you're focusing on one particular solution."

DETECTING CAUSALITY IS REALLY THE STRUCTURING ELEMENT IN PERCEPTION

To an astonishing degree, I learned that eye movement is not just something we do out of curiosity. We literally must keep our eyes moving in order to see:

"Neurons respond to something you fixate on, and then they fatigue. They start to lose their discriminative power when your eyes aren't moving. They respond to change. When you're suppressing eye movements, things become fuzzy or even disappear."

He discussed a landmark study published in 1976 led by scientist John K. Stevens in which subjects were anesthetized but kept awake. With their eyes open but unable to move (saccade), their vision actually faded when they couldn't re-stimulate neurons through eye movement.

Another discovery was even more incredible: when subjects felt the impulse to move their eyes (but could not do it), the image would suddenly be displaced in the direction of the eye movement that was planned but never executed. They were catching their own brains trying to make sense of an image that did not shift as it normally would when the eyes move.

I asked Dr. Rolfs what actually triggers saccades—what makes us look at something?

"When you analyze how many of our saccades are triggered by external events, you'd probably end up with very little. A part of the scene that has high contrast will probably capture your eye movements. But as soon as you have the second or third saccade, the influence of this basic visual information in the scene will become less important. Your own interests and your own task that you have at the moment will be much more influential."

I found the implications of this for individual expression in art fascinating. He also confirmed how differently we attend to familiar vs. unfamiliar scenes:

"If you're in an unknown environment, the influence of these basic properties like salience [things that capture visual attention] will be stronger than when you're in an environment that you know by heart, like your home."

Finally, one of the things that stuck with me the most from our conversation was the way that story—beginning, middle, and end—might literally be wired into our brains:

"Detecting causality is really the structuring element in perception. Just the way you describe the environment is going to have a lot of causal relationships in it: 'The fog is covering the meadow.' There's something behind the fog. Asserting causality in visual events gives you a very rapid way of understanding what happened in the scene. The advantage, evolutionarily speaking, of putting this in a very low-level area [sensory as opposed to cognitive] is that it's a very fast and automatic process that gives you an answer right away without having to engage cognitively with that event."

EXPOSURE

DYNAMIC VS. STATIC EXPOSURE

Wherever we concentrate our gaze, we see normalized exposures. Dark areas are dynamically brightened, light areas are darkened, and as already discussed, we only see a very small area clearly at any given moment. On the other hand, cameras can only capture one exposure for the entire frame, including the darkest to lightest tones. Cameras "look" once and record the entire scene in a single, static frame.

While multiple exposures can be combined, it requires a laborious, special-purpose technique to do it well, particularly if anything is moving in the frame.

LOW-LIGHT VISION

We have two kinds of photoreceptor cells: your 6–7 million cones, concentrated in the fovea, perceive color as well as sharp detail, and are active at higher light levels. Your 120 million rods are much more sensitive, but can't perceive color or sharp detail. This is why you see a fuzzy monochrome image in the dark.

Your peripheral field of vision is dominated by rods, which is why you don't see sharp detail there either. Since rods are not concentrated in your fovea, in low light, you can actually see objects better by not looking directly at them! Rods also have difficulty detecting changes in dark situations.

CAMERAS "LOOK" ONCE AND RECORD THE ENTIRE SCENE IN A SINGLE, STATIC FRAME

This image of a diving board in Norway illustrates several challenges for photographers: first, the reflective light meter inside a camera will incorrectly tell you that this image as I shot it is grossly overexposed, because it is only able to tell you how to render the average brightness of an image at middle gray; second, it is extraordinarily difficult for us to recognize the actual value of photographic tones, because our knowledge of how the subject should look (a white diving board surrounded by ice and snow) tends to override what we're actually seeing (white snow rendered gray by underexposure).

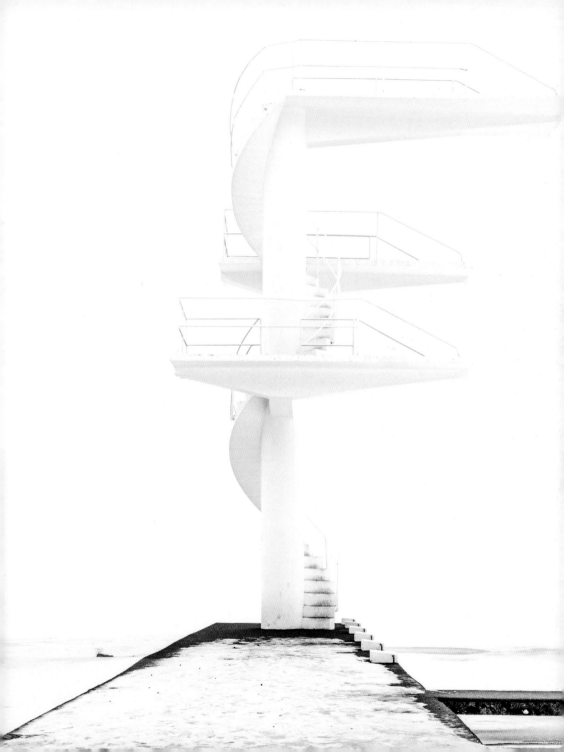

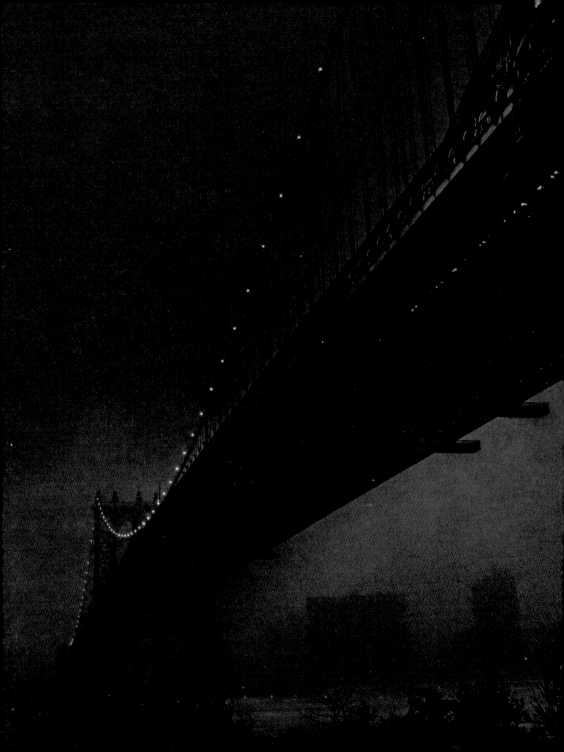

Rather than obsessing over "correct" exposure, I regard exposure as a creative decision. This was shot on a December afternoon during a blizzard. While the scene looked much brighter than this, I wanted to capture what it felt like for such a dense snowstorm to darken what would normally have been a bright afternoon sky. I shot the image as brightly as I could without losing highlight detail, specifically in order to maximize shadow detail under the bridge, then darkened it until it felt the way I wanted.

PHOTOGRAPHS CAN EMBRACE EXTREMES; THEY CAN CREATE VISUAL WORLDS OTHERWISE INVISIBLE TO US

LIMITS OF PHOTOGRAPHIC SENSITIVITY

The sensitivity of cameras to light is not as low as the human visual system, although fast shutter speeds and small apertures can compensate. On the high end, consumer cameras have recently exceeded human sensitivity, with one Sony camera's sensor reaching ISO 409,600 at the time of writing. It's now possible to shoot at hand-holdable shutter speeds by starlight!

WHAT WE LIKE

Given that a camera can gather as much light as it needs through long exposure times, one of photography's most exciting abilities is to record the cumulative effects of light in dark situations, even light that is moving. That, plus the ability to delve into extremely bright and dark images, far from the normalized human view, is one the most under-utilized and visually stunning aspects of the medium.

A camera provides total control over exposure, whereas we can only see a normalized view with our eyes. Photographs can embrace extremes; they can create visual worlds otherwise invisible to us.

DYNAMIC RANGE

Dynamic range is the latitude of tones (brightness) where detail
can be acceptably captured within a single image. Exceed your
camera's dynamic range, and details give way to featureless
black or white. Photographers call this "clipping." We don't
have much experience with this in real life, because our eyes
optimize exposure, masking our limits, while a camera makes
its limitations starkly apparent.

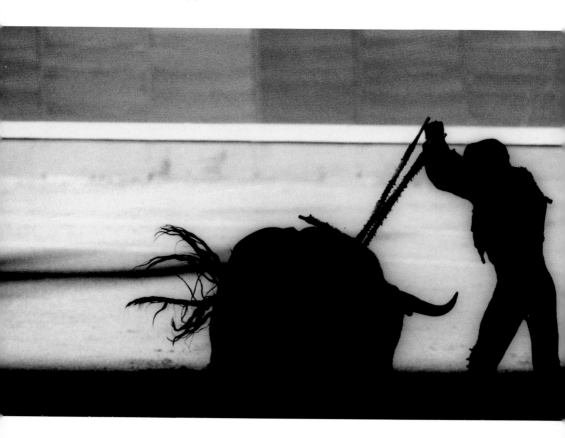

In photography, the word "stop" refers to a doubling or halving of light intensity. Today's digital cameras typically have 11–13 stops of dynamic range. Human beings have about a 21-stop range. This, plus the fact that cameras have only a single exposure whereas humans assemble a sense of scene through many optimized "exposures," means that cameras render higher contrast than the human eye.

HUMAN TONAL RESOLUTION

Our ability to distinguish between similar tones allows us to appreciate subtle shades, but we're much better at resolving subtle tonal differences in highlights than in shadows. In each of the squares along the bottom of the page, there are four circles, equidistant in brightness. We can most easily detect them within the brightest square. Photographers compensate for our lack of sensitivity in shadows by exaggerating tonal differences, as I've done in the enlarged square below, so you can detect the circles more easily.

Matador, from *Los Toros*, 2007.

While technologists never cease trying to expand the dynamic range of cameras to prevent accidental over- or under-exposure, I think one reason we find photographs so compelling is because of their limited dynamic range. Contrast creates drama. Embracing a camera's limitations is a fundamental creative act. If you were to view the scene in Michael Crouser's photograph with your naked eye, you would not see the subject in shadow or silhouette, because our eyes automatically adjust to changing and varied light conditions. The action taking place in the shady area of the scene would be seen in all its detail. But because the image was deliberately exposed by the photographer with regard to the brighter portion of the scene, the background, we are left with an underexposed foreground, giving us the silhouette, deliberately devoid of detail.

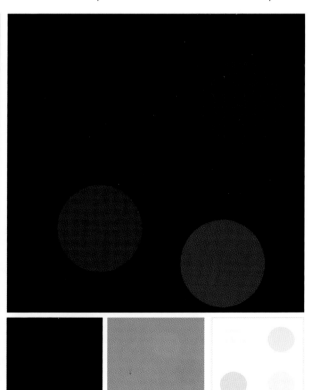

CAMERA TONAL RESOLUTION

The most widely used digital cameras have either 12- or 14-bit sensors, which means that they render 4,096 or 16,384 separate shades of any single color or tone. The most advanced sensors available at the time of writing can capture 65,536 shades of any tone or color. That's especially significant with monochrome or desaturated images, since there is little or no color to help separate elements in the frame.

CONTEXT & PERCEPTION

You'll likely see the circles in the bright sky in the images below as darker than those in the dark sky, but they are exactly the same. You can verify this by putting them side-by-side, eliminating what's fooling your brain: context. Human visual perception is not optimized to correctly identify absolute, mathematical values of tone or color. What we do excel at is comparisons, but that means shifting context can produce an entirely different impression.

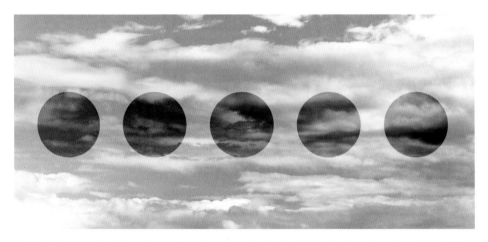

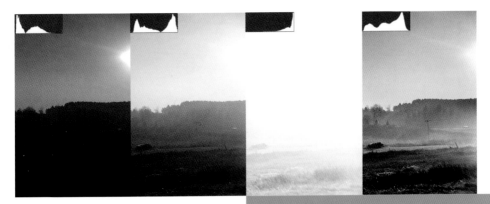

HISTOGRAMS

Here's another example of tonal resolution. The purpose of histograms (shown in the upper left corner of each of the above images) is to show the distribution of tones. The far left photo differs most from what your eyes would have seen because of the dark foreground. The dynamic range of the digital camera was too limited to render both the sky and the ground natural and detailed.

In the second version from the left, the ground still looks darker than I saw it. The third version has been processed brightly. Most of the sky and much of the ground are featureless white. Shadows are no longer shadows.

The last example represents what photographers have to do to overcome these limitations. I chose to darken the sky and lightened the ground. It's a lie that's closest to the truth, and a very typical example of how photographers have to adapt the limits of the medium to the realities of a scene.

Shooting outdoors during the day presents a fundamental and inescapable challenge: there is simply too much contrast for a camera to render both the sky and ground with tones that look natural. A graduated neutral density or polarizer filter can be used to darken the sky, the image can be shot twice and composited, or an exposure can attempt to split the difference, selectively balancing ground and sky exposure later with digital darkroom tools.

HIGH DYNAMIC RANGE (HDR)

Photographers can extend the dynamic range of their images beyond the camera's capabilities by photographing shadows, midtones, and highlights separately and combining them into one image. However, if anything moves or changes, combining images doesn't work very well, making it a specialized technique best suited to non-moving subjects. While it is theoretically a method of overcoming the dynamic range limitations of a camera, it often introduces more problems than it solves.

COLOR PERCEPTION

THE EXPERIENCE OF COLOR

Light is electromagnetic energy that we can see. It is mind-boggling that green leaves appear green because they contain (absorb) every color of light except green, which they repel (reflect). Colors look the way they do because our eyes have three types of cones, sensitive to three wavelengths: red, green, and blue. We are "trichromats," although scientists have recently discovered a few extraordinary humans with a fourth cone—"tetrachromats"— with sensitivity to millions more colors. Only women, with their two X chromosomes, have this potential. Cats and dogs have dichromatic vision—only two cones. Butterflies have five, but they pale compared to mantis shrimp, which have 16 cones. One can only imagine the colors they see.

Color has two components: hue and saturation. Hue is "which color." Saturation is intensity— how far it is from gray—while complete desaturation leaves only grays. Brightness is not a property of color per se; bright red and dark red are the same color, they simply differ in luminance.

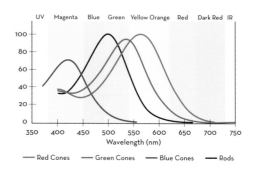

Although following this exercise is going to give you a surprising visual experience, there is nothing magical about the image itself; the magic is in you, the viewer! It's simply an exact negative, in which all of the colors and tones are exactly the opposite of how they looked to the eye. Reds are cyan; yellows are blue, darks are light, etc.

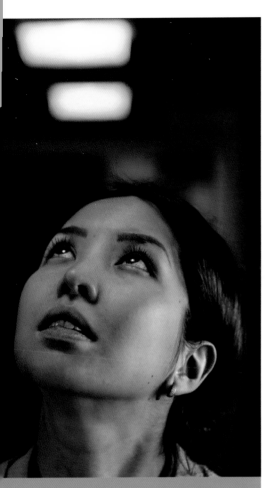

Correctness is not always the goal: here I've deliberately mismatched the white balance setting to both light sources to emphasize the relationship between the colors.

Incidentally, in the dark, we can only see in monochrome.

APPARENT LUMINOSITY

Warm colors (red, orange, and most of all, yellow) are most luminous to us. "Cool" colors (violet, blue) seem least luminous. Therefore warm colors attract more attention than cool colors, a fact exploited by both stoplights and photographers.

THE ILLUSIVE NATURE OF NEUTRALITY

One of things we overlook most easily is the color of light. Not only do our cones get easily fatigued and desensitized to colors, but our pre-existing knowledge blinds us to how colors appear under specific lighting conditions—something photographers have to overcome.

Put a piece of white paper next to this book. Stare at the red dot in the photo opposite for at least 30 seconds, then shift your gaze to the paper and blink. Miraculously, you'll see the real colors of the scene in an afterimage created by your cones, so exhausted by staring at these colors that they become temporarily hypersensitive to their opposites.

Cameras have no pre-existing mental model, no cones. They simply do what you tell them to do. Both film and digital cameras can only render one hue as neutral. This feature is known as "white balance" on a digital camera. It allows the camera to measure color, then neutralize it by adding its exact opposite in equal amount—thus white balance. Once the light source has been made colorless, all colors are "correctly" rendered.

EQUILUMINANCE: THE BRAIN DISAGREEING WITH ITSELF

Color is processed in the brain separately from position, three-dimensionality, object identification, and separation of background from objects (figure/ground differentiation). When these two systems—"Where is it?" and "What is it?"—agree, everything looks normal. When they don't, things can look very strange.

Plus Reversed, 1960.
Richard Anuskiewicz

In the pattern above, the two colors are exactly the same brightness—equiluminant. In the color image above, your "What" system easily sees two patterns because of the contrast in hue. The monochrome image shown left represents what your "Where" system sees: nothing. It is color-blind. Without a difference in brightness, it cannot discern the patterns. Because our "What" and "Where" systems don't see the same thing, the color image seems to shimmer.

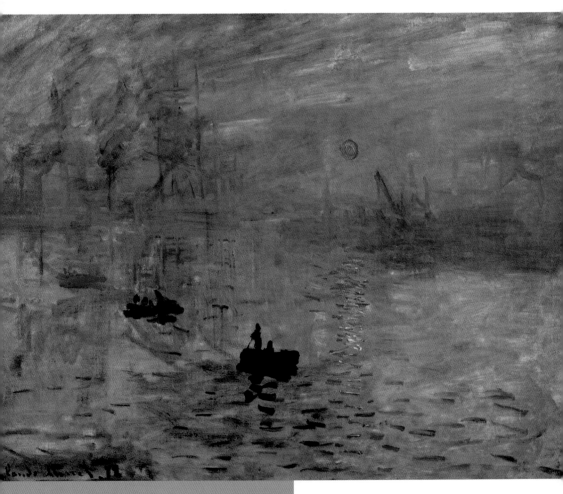

Impression, Sunrise, 1872.

Claude Monet used this principle of equiluminance in this painting to create the same shimmering effect. Few photographers demonstrate a similarly informed application of human visual perception in their work.

MOTION & TIME

TIME & VISUAL PERCEPTION

Time is a funny thing. We are always in it, but we can't see it. It changes us, but it's hard to catch it in the act. Human memories are subjective and changeable, while a photograph captures a finite moment in our unstoppable change, making it increasingly vivid as more time passes since thwe photo is made.

TIME & ATTENTION

We perceive an unbroken, endlessly updated, real-time stream of images. We don't have a shutter. Our brains are constantly comparing the present with the past and imagining the future. As a result, we miss a great deal of what's happening in the present. One of photography's greatest strengths is to show us what we've missed.

TIME & THE CAMERA

We spend 90% of our waking hours with our eyes open, blinking briefly, while cameras spend most of their time with their "eye" closed, "blinking" open to make images by admitting light. The vast majority of photographs are made with exposure times short enough so you can hand-hold your camera without your shaking hands blurring the image, but that barely begins to explore photography's magical abilities with respect to time and motion.

Many photographers simply use shutter speed to adjust exposure. To be fair, if the subject doesn't move relative to the camera, a 30 second exposure can look exactly the same as $^1/_{1000}$ second, provided the total light entering the camera is the same. It's when your subject or your camera is moving or changing that things really get interesting.

Today shutters on consumer cameras typically reach 1/8000 of a second. MIT professor Harold Edgerton invented the modern strobe light, whose short duration he deonstrated in stunning photos of speeding bullets. But even his achievement pales compared to this recent image, from Professor Ramesh Raskar and the Camera Culture Group at the MIT Media Lab, which reveals light itself moving in an exposure of two trillionths of a second. (Visit cameraculture.media.mit.edu)

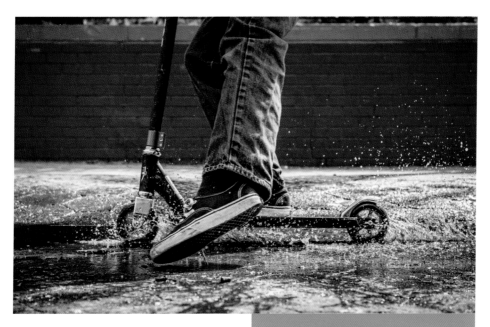

If the exposure is short enough, forms moving so fast that they're invisible to the human eye can be revealed to us, like the water being splashed by this boy riding his scooter through a puddle shot at $1/4000$ second (above).

While the human eye spends most of its time open, and has no "shutter speed," cameras provide a wide range of exposure times. Objects can be blurred through motion, or movement that's either too fast or too slow for the human eye to perceive can be revealed by the camera, as I did with the water in this brief exposure.

Whether or not the subject is moving, the camera itself can be moved to create abstractions. You can keep something stable in the frame by panning the camera even as it moves quickly past something, as I did shooting a fallen telephone line in a frozen swamp from a passing train.

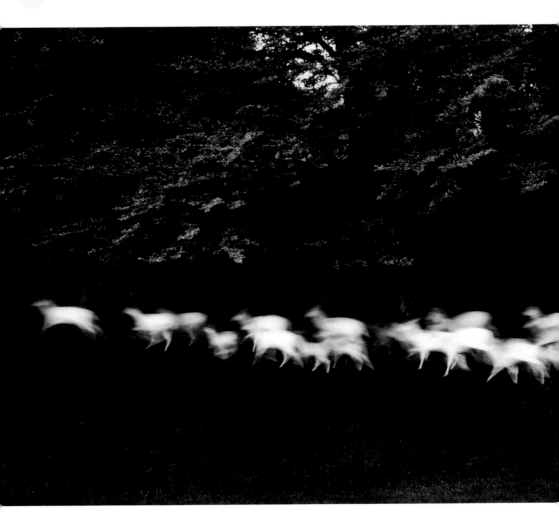

One of the most effective uses of the camera's shutter is to juxtapose movement and stillness, to render some forms with crisp clarity while obscuring or even completely abstracting others that move during the course of the exposure. While master photographer Paul Caponigro carefully planned his photograph of these rare white deer (a necessity when using an enormous large format view camera on a heavy tripod and a lens that admits little light), he had no way of predicting their movements. The available light required a wide-open aperture, a one-second shutter speed, and only a single exposure. When he was ready, he

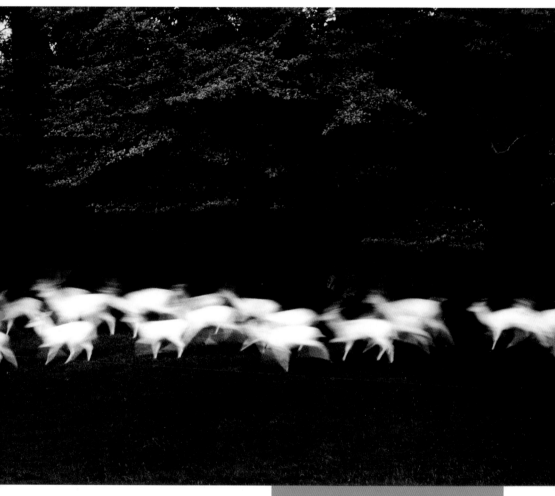

Running White Deer, County Wicklow, Ireland, 1967.

released a dog to startle the deer, and produced an iconic image that manages to convey not only that we're looking at deer, but also a sense of their movement without blurring them beyond recognition. The juxtaposition of their pale moving forms against the still, dark forest only underscores the magical quality of the moment.

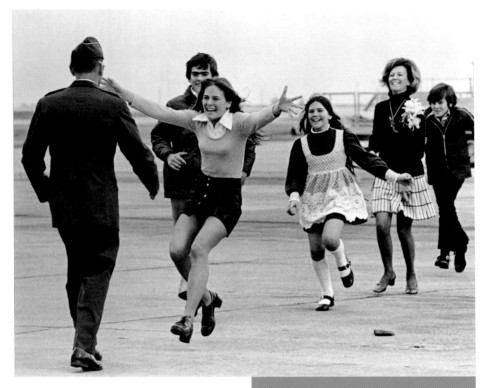

TIME OUTSIDE THE FRAME

A photograph doesn't just contain a period of time in its frame; it can also imply what happened before and what might have happened afterwards. This Pulitzer Prize-winning image by Slava Veder of American soldier Col. Robert Stirm being reunited with his family is a great example. You may not be able to infer that this particular soldier had been a prisoner of war for nearly six years, but you can infer a great deal about the situation.

The less something moves, the more solid it appears in the image. Objects that move quickly never linger in one place long enough for light to collect and solidify their image. They simply disappear.

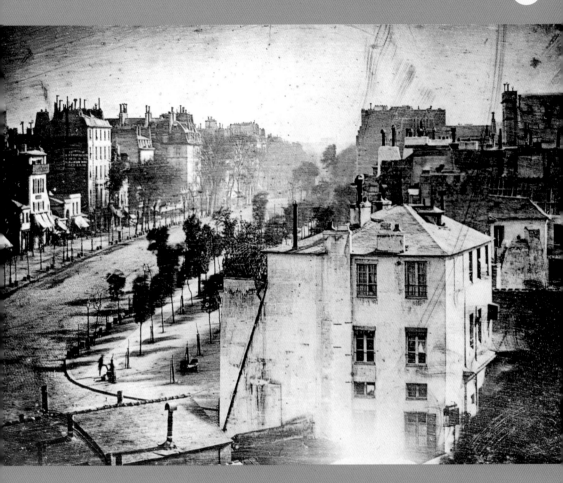

Boulevard du Temple, Paris, 1838

While there are certainly more people in Paris today than there were in 1838, Boulevard du Temple was still sure to have had plenty of people on it when Louis Daguerre's landmark photograph was made — the first known image that contains human figures (at the corner of the street bottom left). Yet why do we only see two figures? The answer is time: the daguerrotype he used required so much light that he had to leave the shutter open for several minutes — so long that the only people who remained still long enough to fix an image were a shoeshiner and his customer.

THE EXPERTS SPEAK
DR. DONALD HOFFMAN, COGNITIVE NEUROSCIENTIST

Although Dr. Donald Hoffman is a professor of Cognitive Science at the University of California in Irvine, his work also encompasses anthropology, mathematics, and even quantum mechanics. His many endeavors include formulating a precise mathematical model of perception, working backwards to understand the human visual system by inferring from the images that we see.

In essence, Dr. Hoffman has studied scientifically rigorous tests and come to some of the same conclusions as this non-scientist photographer: we don't see what we think we see—and we don't see much.

One of his beliefs that most interested me was his position that we don't see what's really out there; we only see what we need to see. This contradicts what Dr. Hoffman calls the standard view in his field, that the most accurate perceptions are what's best for our survival. He's used evolutionary game theory to demonstrate that perceptual functions designed for accuracy are driven to extinction by those just tuned for survival:

WE DON'T SEE WHAT'S REALLY OUT THERE;
WE ONLY SEE WHAT WE NEED TO SEE

"We have limited capacities, so we have to have limited perceptions, but it's even deeper: fitness functions don't generally track the truth. Whatever reality might be, one can show that the likelihood that the fitness functions that govern us are actually reflective of that structure is precisely zero."

In his many essays and talks, he's elaborated that our perceptions are optimized to allow us to act quickly and survive. So while we have to take our perceptions seriously to avoid danger, we shouldn't take them literally:

"The perceptual systems that we have evolved for just one purpose, to keep us alive. They are not the truth; they are simply a species-specific guide to behavior."

Dr. Hoffman uses the metaphor of a computer's operating system to try to explain what he calls our "species-specific hack."

"When you drag an icon to the trash can, you are changing voltages inside the computer. But you have no idea what you're really doing. All you know is that this blue square icon moved over to the trash can icon and then disappeared."

"The normal observer doesn't realize they are interacting with a true reality that's utterly different than anything you experience. There are no blue icons inside the computer. There are voltages and magnetic fields that are really, really complicated."

Dr. Hoffman speculated that we might be ill-equipped not only to see what's really out there, but even to conceptualize how the world actually works:

"I think it's quite possible that a chimpanzee could never understand quantum mechanics, because they simply don't have the right concepts. And I'm just a slightly more complicated chimpanzee, frankly. So there's no reason for me to expect that I have the right concepts to understand reality as it is."

I asked him what he would change about the human perceptual system:

"I can only see a certain range of colors. I can only see three-dimensional space. I know that mantis shrimp have 16 cones. Pigeons have at least four. They're perhaps living in a richer color world than I can even concretely imagine. I would love to have perception that would allow me to have an insight into reality as it is."

"It's very interesting that as a species, our cognitive and perceptual framework, which is in some sense our window on the world, is also our prison. We cannot get out. The only way that we're able to somewhat is through science and mathematics."

Can art do the same, or does it just reflect the limits of our perception?

2

HOW WE NOTICE
PRINCIPLES OF VISUAL ATTRACTION

OVERCOMING THE BANDWIDTH OF PERCEPTION

Scientists have estimated that only 0.0003–0.0004% of all sensory input ever reaches our conscious awareness. This is not a bad thing. Imagine that you had to consciously think about every sensation you heard, smelled, saw, tasted, and felt from moment to moment. You'd be flooded with information. Even worse, if you had to consciously process all of this information before you could decide what to do with it, you'd never survive. Consciousness is not only very limited, it's slow. The funny thing is that we tend to think of this tiny sliver of conscious awareness as the entire "us." We give consciousness credit for everything that we do and are, when it is just a drop of water in a vast ocean.

To grasp the absurdity of this, imagine that you've been offered a job. You've been given a large office and in it are a huge spinning globe, 7.5 billion thumbtacks, and a TV with 7.5 billion CCTV channels. Each channel shows a real-time view of one person. Your job is to monitor those 7.5 billion channels and keep your world map updated with thumbtacks showing the exact position of every person on the planet in real time.

If you're sensible, you would turn down this job because you recognize that it's impossible. You know that you can't manage it. But when it comes to our own behavior, we confidently believe that we see all. We think that we make conscious, rational decisions with full awareness of the pros and cons, when in fact we're only aware of a minute fraction of our perceptions and decision-making processes.

Between our two ears is the most complex organ in the known universe. One human brain contains more synaptic connections than there are atoms in the universe. Our own few pounds of brain tissue contain the greatest mystery in the universe; we've barely begun to understand ourselves.

Given that we think we see a lot more than we actually do, photographs have a startling tendency to show us not only what we miss, but what we didn't know we knew—perceptions we recorded, reacted to, but never reached conscious awareness. Photographs reveal photographers both to themselves and to others, and even mirror a viewer's outlook.

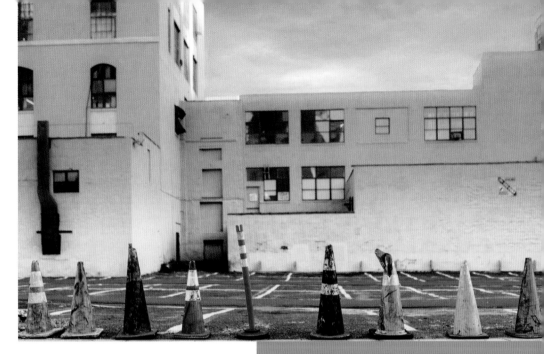

TRANSLATING ATTENTION

When you make a photo, you're not just trying to show what you saw, but what you thought. You're not simply transmitting an image to a camera, you're trying to communicate an idea.

When we're new to cameras, we stand at a polite distance and shoot very general wide shots. Our intention is clear to ourselves, because our thoughts are a spotlight that focuses our attention within the scene. But these photos are chaotic, with an overwhelming number of details, none of them particularly emergent. Viewers don't see what you saw because they can't know what you thought.

Stripped of the thoughts of the maker, a photograph has to direct the attention of the viewer using the language of photography, to place emphasis and communicate themes and ideas through visual grammar.

The chief goal of a photograph is to provoke the viewer not just to look, but to actively think and assign their own meaning. Here, I hoped to suggest that this line-up of battered cones looked like a line-up of colorful characters with distinctive personalities and histories.

It's not difficult to grab a viewer's attention—but that isn't enough. You also have to make room for the minds of your viewers. What makes images truly successful is not just the clear communication of an idea to the viewer, but the presentation of an experience that is *initiated* by the photographer, and *completed* by the viewer.

Successful images direct attention and suggest ideas, but they also have a certain degree of ambiguity. They encourage viewers to be active participants who co-create the final meaning of an image.

POSITION IN FRAME

PERCEPTION & POSITION

As you know, we can only see 1–2% of our entire field of vision clearly (see page 16). So when we look at a photograph, it's natural to choose the best perspective: dead center. We stand back so we can take in the entire frame. When we center ourselves in front of an image and scan it, the spot we inevitably cross the most is the middle. Thus we're likely to notice what's closest to the center of an image: elements closest to the edges take us the longest to discover.

A subject placed dead center can be calming or comical, but you don't have to be a master carpenter to notice when something is not quite centered, as with the image of an eye looking through a traffic cone (right). It's tricky to make not-quite-centered within an image feel decisive rather than like a compositional oversight. Not-quite-centered is disconcerting; it violates the sense of order that we seek in photographs.

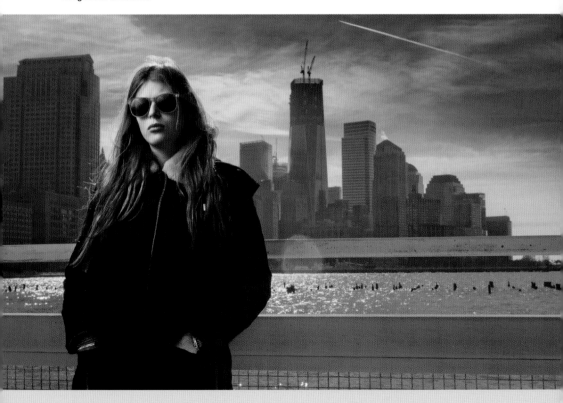

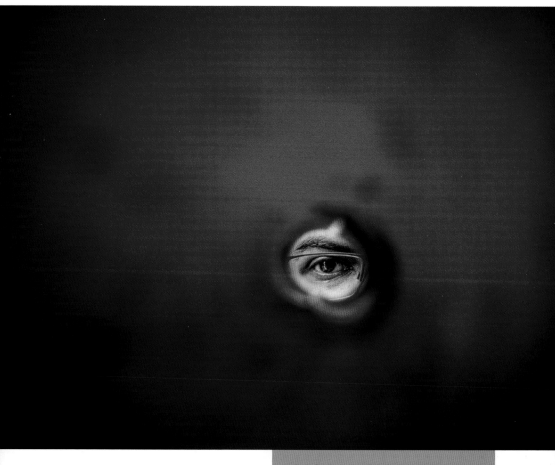

Since the majority of this composition is a mostly featureless red blur, the viewer's eye is inevitably drawn to the eye looking back at them. But the odd placement of the eye is neither centered nor far enough from center to balance the composition, leaving the viewer unsatisfied.

It's more common to shift key elements within a composition farther from the center, as in the position of my friend Connie in front of the New York City skyline (left).

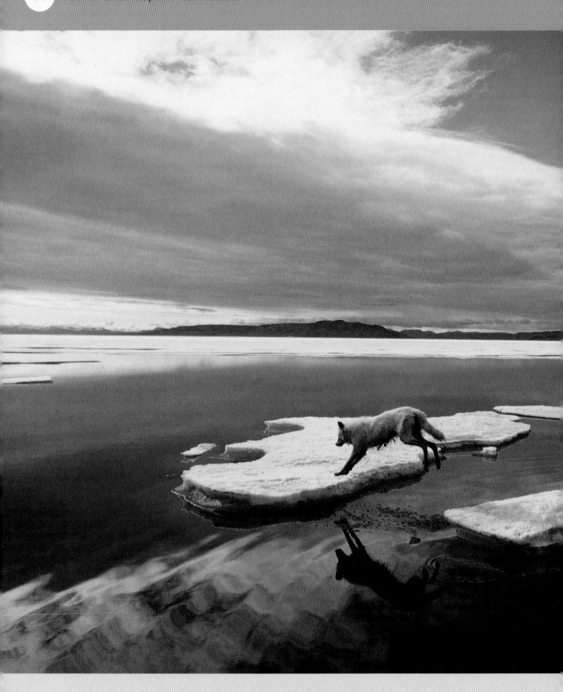

Or make your subject centered on at least one axis, as Jim Brandenburg did in his amazing capture of an arctic wolf leaping between ice flows (left).

While the wolf itself is slightly left of center, the group of ice floes, the dark water mirroring the wolf, and the wolf itself very much occupy the horizontal middle, and comprise the primary subject. While it's possible that he might have wished to have had tripped the shutter a split second sooner when the wolf was perfectly centered at its apogee, Voltaire was not the only one to observe that "the perfect is the enemy of the good."

Arctic wolf leaping, Canada, 2009.

Centering the wolf and surrounding it with so much open space apparently devoid of solid land or other wolves underscore the wolf's isolation, the mystery of how it came to be in this position in the first place, and what its future might be. Brandenburg was also careful to place the horizon line centered on the vertical axis as well as finding a slanting line of clouds that mirror the diagonal channel of water between the ice floes, lending his iconic image an even greater formality and visual balance.

SIZE IN FRAME

We may stand at a distance from an isolated farm to consider what it would be like to live there, how far away the neighbors are, how this might have been a forest before it was a field, but if we want to shift focus to a colony of ants in that field, we have to make those details significantly larger in the frame by moving the camera.

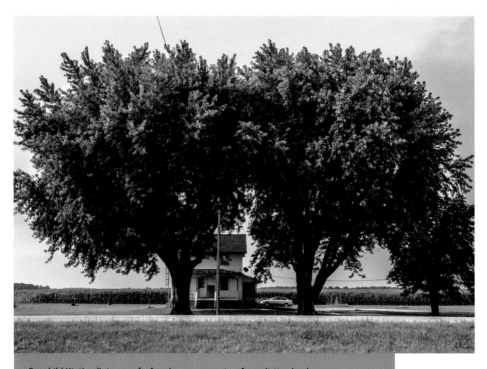

Ragnhild Kjetland's image of a farmhouse presents a formalistic, deadpan view based in a long tradition of documentary photography that avoids overt commentary in favor of simply presenting something for our consideration: two trees that have undoubtedly seen many occupants of that house come and go, or even multiple houses in their long lives.

We lose that control when looking at photographs. The size the photographer renders each element in the frame determines how easily we can see, how much information we can glean, and how quickly we notice things. Size also functions as rank: larger elements tend to assume a greater role. We see them first, presuming they are of interest at all. Smaller elements usually take us longer to locate unless they stand out for other reasons (position, color, etc.). Keeping elements small is another way a photographer can delay perception.

SIZES & TYPOLOGIES

Equalizing object sizes within a single image or across a series of images invites us to compare them, to notice the differences. Photographers call this a typology. Among the most strict practitioners of this approach were Hilla and Bernd Becher, who used a large format camera to photograph industrial structures using an identical perspective and soft light, and often presented the resulting images in a grid. The presentation of subjects in the most even-handed, consistent way possible invites us to compare related objects on equal terms—apples to apples, if you will.

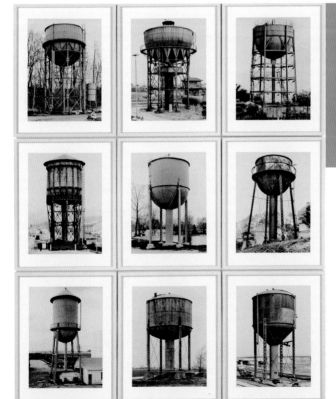

Water Towers, 1980

The Bechers' monumental studies of industrial structures demonstrate the value of a rigorous, formal, and consistent artistic form, created through matching perspective, composition, and lighting.

SCALE

As objects move farther away, they appear smaller. Below, you see tourists taking selfies on a boat and water which you expect to be New York Harbor. But even though the little green statue looks about the same size as the phones trying to capture it, why don't you think that the statue might be one of those souvenirs sold in Times Square gift shops?

In truth, you have no way of knowing whether this is the real Statue of Liberty or actually a carefully constructed fake. It probably feels safer to assume that this is the real statue. After all, who would go to such elaborate lengths just to play a trick on you? Well, quite a few artists, it turns out, do just that, confronting our reflexive assumption of truth in photographs. Three notable examples are shown opposite and overleaf.

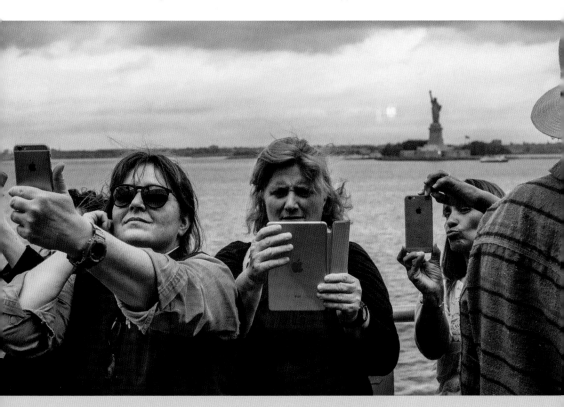

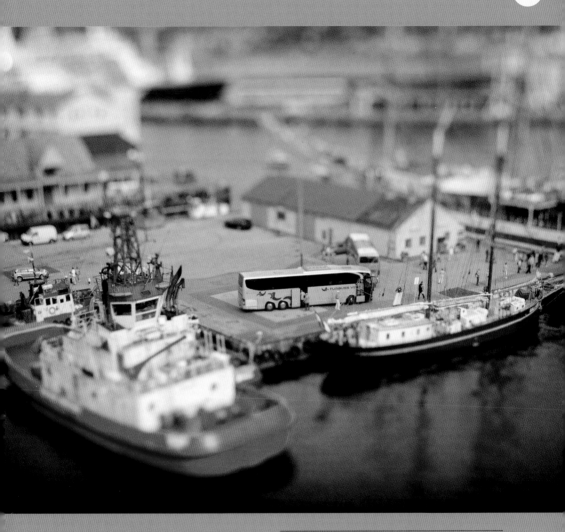

Tall Ships and Bus

Bjarte Bjørkum's image of a full-sized
Norwegian pier uses the same selective
depth of field of macro photographs to
disorienting effect.

QUITE A FEW ARTISTS CONFRONT
OUR REFLEXIVE ASSUMPTION
OF TRUTH IN PHOTOGRAPHS

OUR BRAINS IGNORE VISUAL SIZE, AND "SEE" THINGS AS THEIR ACTUAL SIZE

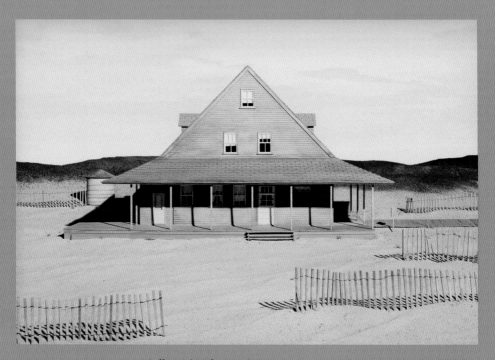

*Caffey's Inlet Lifesaving Station,
Dare County, North Carolina, 2013.*

James Casebere aims to do the same,
but in reverse: he invites you to think
that you're looking at a real place, but
it's a miniature model that he meticulously
constructed. He carefully eliminates any
hints that this is not life-size.

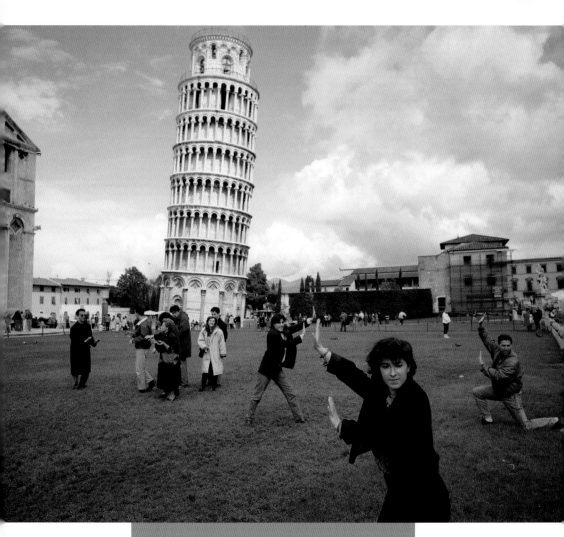

The Leaning Tower of Pisa. From *Small World*, 1990.

Martin Parr shows that humans have an innate understanding of scale, pretending to be the reason that the leaning tower of Pisa hasn't yet fallen. Photographers can also transform scale through print size. Vast landscapes can be contained in tiny prints. Tiny details can engulf us in enormous prints, giving us an otherwise impossible experience of them.

FOCUS

Being confronted with images that are profoundly out of focus
is so foreign to us that I think some photographers are simply unsettled
by it. They become obsessed with sharpness. They work overtime to
render everything as sharply as possible.

Purists throughout history have waxed furious:
blur is unnatural! Pure photography must
emulate the human experience as faithfully as
possible! Famous practitioners including Ansel
Adams, Imogen Cunningham, and Edward
Weston even created a manifesto they called
Group *f*/64 to leave no doubt that, in their

Dunes, Oceano, 1936.

Edward Weston's image of sand dunes
perfectly illustrates his belief that photography
should provide sharply focused images. His use
of a large-format camera and contact printing
underscored his preference with he highest
possible level of detail.

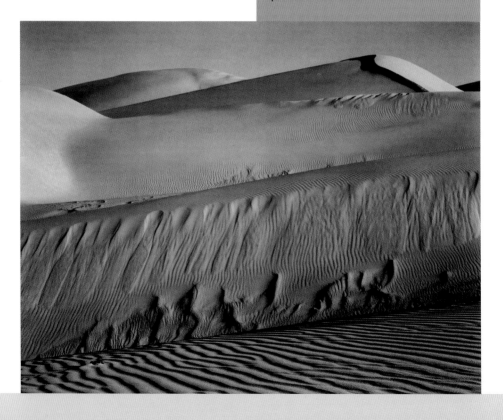

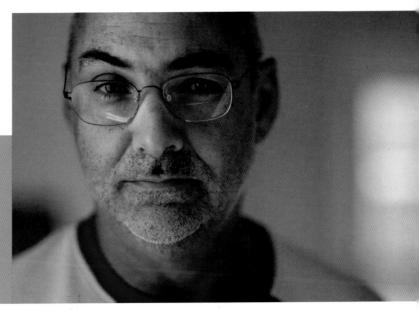

Sharp focus commands the viewer: Look here! This is important! It's comfortable looking at focused subjects. Using selective focus is useful to minimize distractions, as in this portrait of my friend Paul.

opinion, everything should be sharply focused. While no one can deny the contributions of these masters, I suspect that the passionate intellectual justifications for sharp focus are based in biology: blur makes us uncomfortable.

Humans cannot look around without shifting focus, nor can they vary their depth of field. The fuzzy image you see in your peripheral vision is vague not because it is blurred, but because it's essentially low resolution. There is no exact photographic equivalent.

I'm not sure that the primitive part of our image-decoding brains really differentiates between looking at a reproduction of the world and a direct view. Both provoke the same sensation. The viewer's eye roams through the frame, trying to bring objects into focus—only it can't. The photographer controls focus.

Blur might seem to communicate "nothing to see here" to the viewer—and that is certainly one use of it. Focusing on one thing makes it "pop" out of the space around it. But blur can also lie about an element's importance. Blur motivates the viewer's eye to look past it, to assume that blurred objects are less important than sharp areas.

The viewer's eye will linger primarily on the sharp areas because it's disconcerting to stare at objects we can't bring into focus. However, if those blurred elements are important, the attentive viewer will eventually realize: this matters. That jolt of realization is the Holy Grail of the viewing experience.

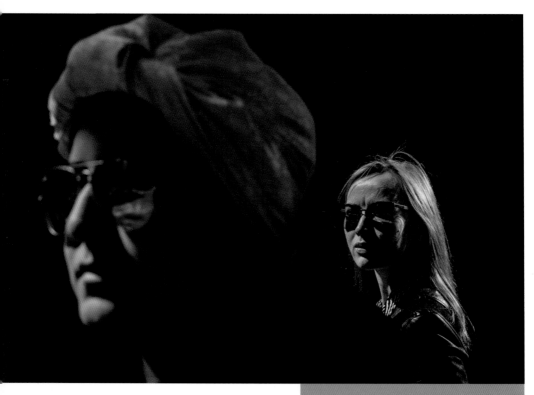

The order in which viewers notice elements of a composition can be controlled in many ways; focus is just one of them. But using focus to slow down that perceptual experience can create a rapid-fire sequence of assumptions: "I know what's going on here. I know what this image means. Hold on—what?!" The more deeply the photographer can create misleading assumptions, the stronger the shock is when the viewer recognizes something that challenges those assumptions.

Both of these photographs are from a series about the idea of trust and mistrust. In the image above, the size of the woman's head on the left suggests that she's important to the story, but the focus contradicts that idea. These elements, plus the way the sharply focused woman at right seems to be regarding her with suspicion, leads the eye to jump back and forth between them. Mistrust and discomfort are themselves both the subject and the experience of the image.

When elements are defocused, it's usually for straightforward reasons: to concentrate visual attention on a subject elsewhere in the frame, to simplify a busy scene, and simply because those elements are inconsequential to the idea behind the image. But another use of deliberate blur is to trick the viewer's eye into initially skipping over the defocused elements, but to use some of the other visual attractors described in this chapter to force the eye to eventually return to them and reconsider their importance to the theme. It's another method of slowing down and prolonging the viewer experience.

Again, I've placed a large figure in the foreground but used it to interrupt and obscure what we most want to see—the woman's face. Making it diffiicult to find her eyes and see them clearly echoes the tension in the look between her and us, giving the image itself an air of suspicion or surreptitiousness.

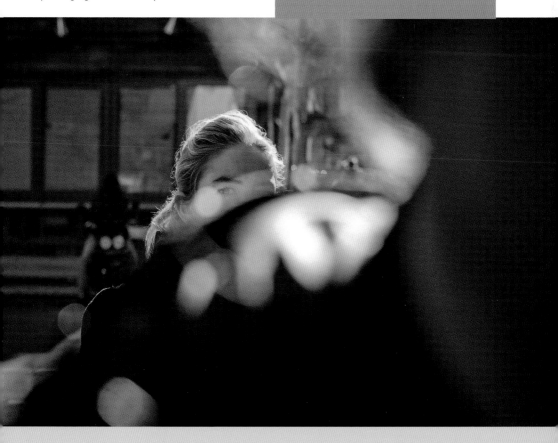

LINES, REAL & IMPLIED

Our remarkable balance system allows us to perform amazing physical feats while remaining on our feet despite the force of gravity. But there is a byproduct of balance that has a surprising effect on how we see photographs: we have all become authorities on horizontals and verticals. We spend the majority of our waking hours upright. That means we develop an intimate familiarity with a level horizon, and with trees and buildings that soar vertically above us.

You can feel this for yourself: in images where the photographer has taken the trouble to match our usual upright view, the straightness of the horizon has a stabilizing effect on us. When the horizon is askew, it has an unsettling

In the photo below, the formal straightness of the horizon and vertical poles echoes the presence of lines throughout this image.

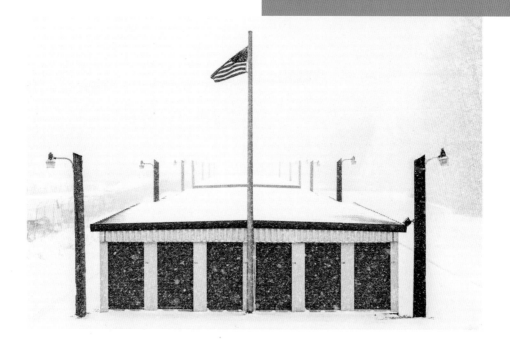

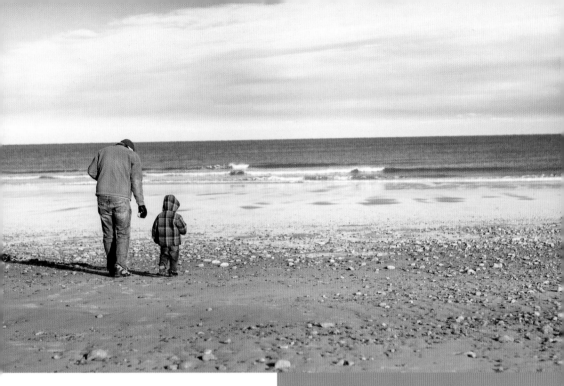

effect. A viewer's eye roams over the image, looking for a comfortable place to land. We recognize when the world is even slightly tilted.

When faced with the challenges of handling a camera, it's very common to overlook whether the camera is level, as I did in the beach photo above. Accidentally or tentatively tip-toeing into a stylistic or unconventional choice often feels indecisive or indicates oversight. As viewers, we want to feel a sense of confidence, that we are being asked to pay attention to an image that has been deliberately and authoritatively constructed, one that will reward our investment of time.

Many images are weakened by ideas that would seem more assured if they were pushed further. Jazz musician Miles Davis described how a mistake could be turned into a choice

I've long used this image to show students what not to do. Not only did I fail to get the horizon straight, I also should have lowered the camera to avoid placing the man's head so close to the horizon line. Both mistakes weaken the composition considerably.

when he stated, "If you hit a wrong note, it's the next note that you play that determines if it's good or bad."

Perhaps we sense that it's easy to accidentally hand-hold a camera at a slight angle, but it takes deliberate effort to skew it at unusual angles. Of course, bold choices come with risks: a radically tilted horizon draws attention to itself, and can be a distraction or gimmick if it doesn't serve to underscore an idea.

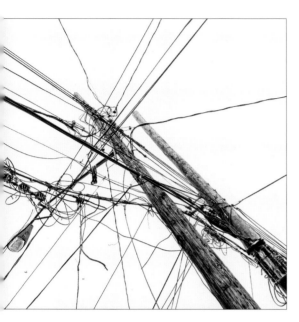

In this image of telephone wires run amok, I radically tilted all of the lines, including the vertical wooden poles, to communicate a feeling of an uncomfortable world that must be a bit mad to construct such sights in residential neighborhoods and not consider their effect on us.

The viewer's eye tends to move through diagonals, perhaps driven by a sensation of losing our balance. Photographers learn to utilize diagonal lines to direct the attention of the viewer. Often called "leading lines," they're effective at directing the eye to more stable (and hopefully interesting) points of interest. In this wonderful example below, David Burnett positioned himself so the cable line sliced diagonally through the image and the murky darkness surrounding it, pointing our attention directly to the boy hanging from it.

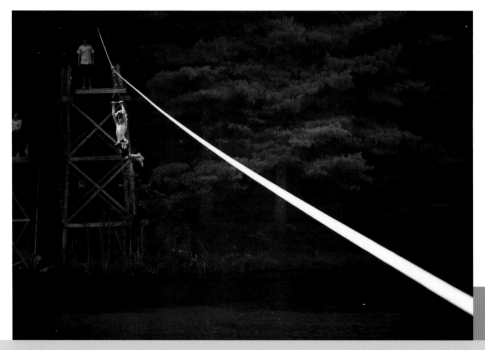

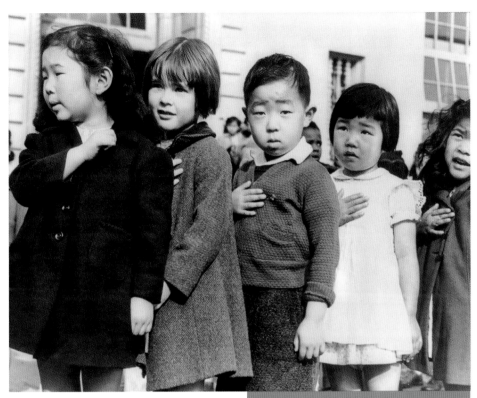

Japanese children pledge allegiance to the United States flag, 1942.

REAL VS. IMPLIED LINES

We don't notice only literal lines in a photo; we imagine vectors that connect particularly significant elements. Gestalt psychologists call this phenomenon continuity, and you can see it in the way your eye jumps from head to head and across the hands held over hearts in Dorothea Lange's image of children pledging allegiance in an internment camp where Japanese–Americans were held. Our tendency to "connect the dots" in this way depends on an internalized hierarchy of interest. As our eyes saccade across an image, they illuminate this hierarchy by pausing on what we find most salient. Human beings, particularly their faces, typically interest us the most. Because we linger on specificities and don't spend equal time examining a blue sky and a human face, for instance, we infer lines between the highest ranking objects in an image by saccading between them.

Boy's Camp, NC.

EXPRESSION & GESTURE

Above all, we look for ourselves in photos, for human beings and
human qualities. We imagine what it would be like to be the people
in the photograph, even when it is almost impossible to imagine.
Photos are a silent medium, devoid of voices, but body language
and facial expressions convey much in the way of story and character.

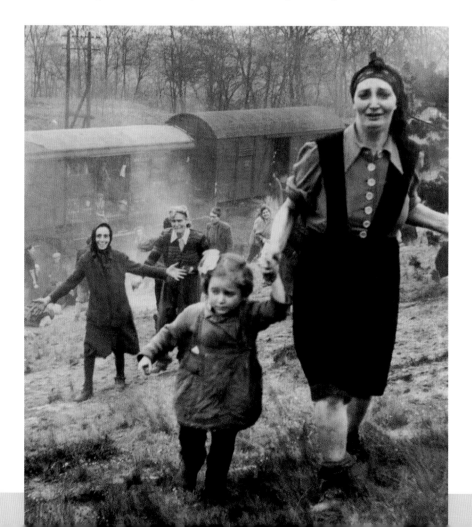

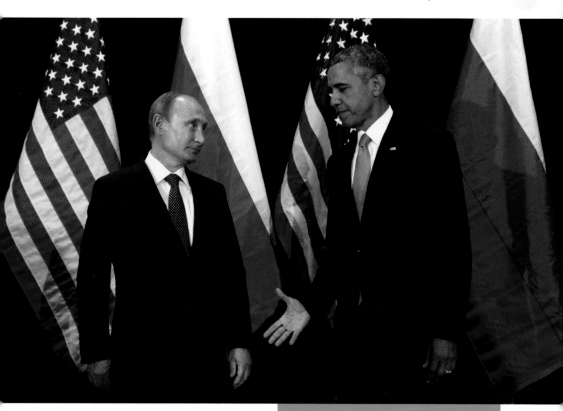

Even without reading any kind of caption, anyone remotely familiar with twentieth-century history can probably guess the approximate time and circumstances of the heart-stopping image shown opposite. Made April 13, 1945, Major Clarence L. Benjamin portrays former inmates of the Nazi Bergen-Belsen concentration camp at the moment they've just realized that the American soldiers are there to liberate them. The expression of emerging hope and emotion on the face of the foreground woman and the open arms and joyful face of the woman on the left capture our attention and convey more than words could say.

President Barack Obama extends his hand to Russian President Vladimir Putin, 2015.

On a lighter note, photojournalist Kevin Lamarque brilliantly captured a precise moment in which gesture and facial expressions tell the entire story of the willingness of two politicians to cooperate with each other.

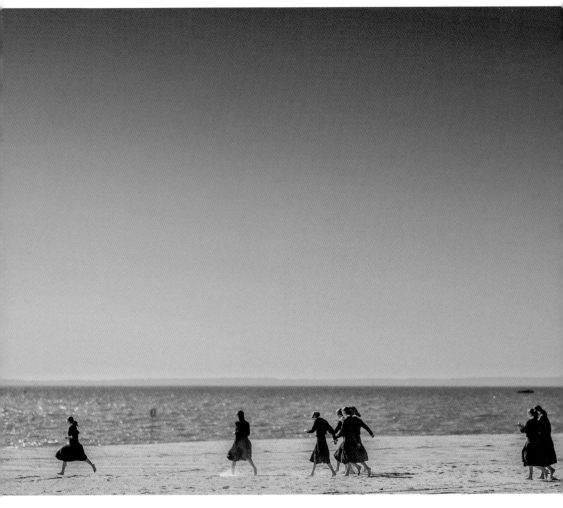

I found the way in which these New York City orthodox Jewish schoolgirls ran shoeless onto Coney Island beach on an unseasonably warm November day very poignant.

Psychologist Paul Ekman studied human facial expressions for decades, discovering not only that authentic emotions are conveyed by involuntary facial muscles, but that they are universal, not culture-specific.

What's most interesting with respect to photography is that these micro-expressions are fleeting, lasting a fraction of a second. Although that may be too brief for us to be consciously aware of them, split-second

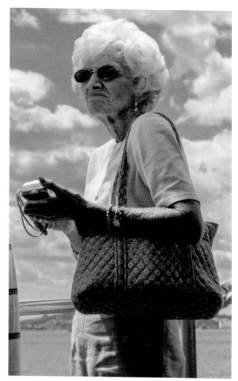

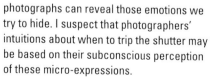

SPLIT-SECOND PHOTOGRAPHS
CAN REVEAL THOSE EMOTIONS
WE TRY TO HIDE

photographs can reveal those emotions we try to hide. I suspect that photographers' intuitions about when to trip the shutter may be based on their subconscious perception of these micro-expressions.

SUBSTITUTION

The thesis of this entire book is that the highly selective nature of our own real-time perception sets us up to be surprised by photographs. We are surprised both because our pre-existing expectations are so thorough that we actually see very little, together with the irony that we think we see quite thoroughly. The higher something ranks in our hierarchy of attention, the more vivid is our shock when it is not as expected. When something expected and important is substituted with something similar but surprising, the principle of substitution makes us do a double take.

If we weren't so sure that we'd see a human face above the legs of this dog owner, we wouldn't be so surprised and amused that the infamously observant and mischievous photographer Elliott Erwitt caught a bulldog looking back at us.

It helps that the size of the bulldog's head is comparable to the person's, and that it covers the owner precisely. The black and white tonal palette also helps minimize the differences between the dog and the person on whose lap it's sitting.

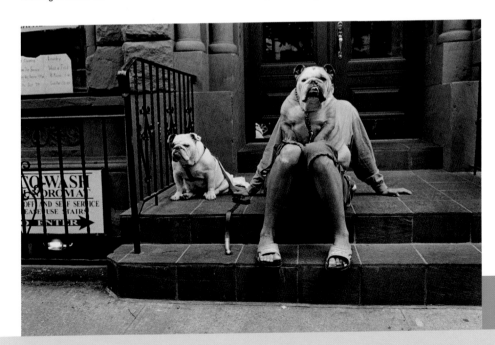

While face substitutions are probably the most fascinating to us, almost anything comparable in shape and size can be substituted to great effect. The jolt of surprise and laughter works the same way as in a good joke: you're sure of what you're going to see, until confronted with the absurd.

New Bond Street, London, 2006.

Here, street photographer Matt Stuart manages to find a tarp-covered dumpster in just the right place to become a peacock's body, complete with traffic cone feet.

New York City, USA, 2000. Elliott Erwitt.

ATTENTION
THE PERSONAL HIERARCHY

All things are not observed equally. When our eyes ping-pong across a scene, where and how long they linger maps a hidden, personal hierarchy of significance. It traces our thinking process as we try to decode an image.

We notice those things that we can name, those things that raise questions, those things we can physically contact. Things that have the highest value to us emerge from the frame. The sky tends to function as negative space, a "nothing" rather than a "thing", such as a tree. People and humanoid forms get our greatest attention. We also seem to understand the world as much through our physical contact with it as by seeing it. Our brains exhaustively catalog and recognize things: tools, food, rocks, trees, animals, other people, buildings. Objects with boundaries that we have experienced seem to hold more attention: a boat gets more saccade time than the ocean on which it's floating.

Let your eyes roam through this photo for a minute. It's complex. Where does your gaze return to the most? Red cube, sky, pedestrian, curtains? What about the surface of the building itself? The FedEx logo?

While this chapter illustrates many reasons for visual attention, ultimately your own attention maps your experience and interests in a very personal way.

There are many places to look in this image. If you install fences or drive trucks for a living, your attention may be directed there. Perhaps you owned a car similar to the white one at left. Maybe you recognize the landscape of the American Southwest, or even Utah's Canyonlands National Park. You may be mystified by the white object emerging from the back of the orange truck, even though it's tiny in the frame. You may recognize it as a dinosaur, like those whose bones were found not far from where the photo was taken.

THE EXPERTS SPEAK
DR. JAY FRIEDENBERG, PSYCHOLOGIST

Dr. Jay Friedenberg is an experimental psychologist and Professor of the Psychology Department at Manhattan College in New York, where he teaches courses in sensation and perception, artificial intelligence and biological psychology. He has written several textbooks on cognitive science.

We began by discussing the differences between sensation, perception, and awareness. He clarified that we can perceive things but remain unaware of them; we can even look right at something, but have it remain subconscious, a phenomenon known as inattentional blindness. He talked about how expectations have a physiological effect on our neurons:

"All neurons have a baseline firing rate. Priming is going to change that firing rate and make them more likely to respond. When you are primed to see something, you're increasing sensitivity. You're making the likelihood that you're going to activate a neuron greater."

WE FEEL LIKE WE'RE TAKING IT ALL IN, BUT THERE'S ONLY A VERY SMALL AMOUNT THAT GETS TO CONSCIOUS AWARENESS

He went on to talk about just how little of our sensory input we're consciously aware:

"We feel like we're taking it all in, but there's only a very small amount that gets to conscious awareness. It's called the attentional bottleneck. But it makes sense. You don't want to take it all in. It'd be overwhelming. You only need to be aware of those things that are important for you, that are going to affect what you're going to do next. It's like perception in the service of action."

He discussed the famous case of a patient known as TN: a series of strokes left him unable to see—not because of his eyes, but because he no longer had mental access to what they saw, a condition known as "blindsight." Yet tests (https://youtu.be/4x0HXC59Huw) revealed that he acted on perceptions that he wasn't even aware of having. Dr. Friedenberg explained:

"The part of your visual system that controls your eye movements is below attentional awareness. You don't make a conscious effort to look over here, look over there. If you had to, things would be slowed down so much that you wouldn't be able to function."

He explained that perception combines visual input and intentional thought:

"In bottom-up perception, your percepts are being driven by the information that's 'out there.' Top-down perception is based on what you already know, what you're predisposed to expect, and also what you've learned over time—memory. Normal perception involves both: it's perceptually and conceptually driven. What you know influences what you see."

I found it especially interesting to consider this in light of how photographers have to work from an inward idea, but nevertheless require an external subject placed in front of the camera in order to express that idea. Dr. Friedenberg summarized what gives something "salience"—its tendency to stand out from everything else:

"Salience operates off of differences between an object and its surround: color, contrast. Any sudden motion triggers an orienting reflex, because it has potential significance for your survival. You would hear your name almost instantly, even with lots of background noise. There are certain characteristics that we are attuned to. It's kind of like they get the express track."

Lastly, he made an interesting point that while heightened perception is necessary for creativity, they are not the same thing:

"Your right hemisphere tends to be more spatial, your left tends to be a bit more verbal and analytical, although you use both. According to one theory, the left hemisphere inhibits the right hemisphere, but in some autistic individuals, that inhibition is removed, which helps explain their drawing abilities. But they're just reproducing what they're seeing. Creativity in any field requires both hemispheres."

BRIGHTNESS & CONTRAST

Light doesn't just make things visible; it makes us notice. When contextualized by darker areas, light is similar to a spotlight on a dark stage: it leaves no doubt as to what we're supposed to notice first, while darkness can delay the viewer's perception.

I used the phone camera I had in my pocket to snap this study at left in high contrast on a clear autumn day, waiting for the figures to enter the space where the large shadow areas converged.

DARKNESS CAN DELAY THE VIEWER'S PERCEPTION

Luge (2002 Olympic Winter Games).

If everything in an image is equally lit within a narrow tonal range, light isn't so much employed to direct attention as simply to illuminate. The viewer's eye roams based on other criteria. Contrast also gets our attention. Raymond Meeks demonstrates keen awareness of this by selectively enhancing contrast on the luge rider.

Trang Tran created this masterful high-key portrait (opposite) back when I was fortunate to have her as a student, while my image of a New York City skateboarder (above) embraces a low-key palette.

EXPOSURE: CREATIVE vs. CORRECT

Among the most rewarding aspects of photography are the ways it gives us control over visual aspects that we can't control with our eyes. Exposure is one of the most under-utilized of those. It takes considerable effort to learn just how far you can stretch believability without creating something that looks unrealistic or artificial.

Images that exist in a narrowly constrained bright (high-key) or dark (low-key) tonal range are consistently compelling, doubtless because our eyes only show us normalized exposures.

Moving beyond "normal" exposure defies the idea that photography should be as close to the human viewing experience as possible. While this may be true for photojournalists, photography provides opportunities to create myriad images that the human eye simply cannot see.

The way that photography can keep highlights bright and shadows dark simultaneously, whereas our eyes quickly optimize exposure wherever we look, is one of the aspects of the medium that we find so compelling.

TONAL FRAMEWORKS

While many photographers like to obsess about getting better equipment, the playing field is very level at this point in history. Digital technology makes the limitations of our tools even more equal: an 8-bit image can contain exactly 16,777,216 colors, no more. So why do some photographers' images just seem to have that magic? Why do their colors and tones just seem so extraordinary?

The answer is not that they have secret special tools. It is the use of juxtaposition and restraint. Context is everything. If you want to make something seem extraordinarily luminous, surround it with darkness. If you want to emphasize a red, contextualize it with a complementary cool color. George DeWolfe illustrates this perfectly in his exquisitely rendered image of a bunchberry plant, shown opposite.

Bunchberry,
George DeWolfe.

A tonal framework is an area of closely related tones. A restrained tonal framework gives a more dramatic context for details that are outside of that narrow tonal range than simply using a full tonal range everywhere. There are also images that consist only of narrowly constrained mid tones, like the one at right of Beijing on a smoggy morning. The red neon sign is the most emergent detail. Given time for the eyes to adjust, we can appreciate subtle tonal differences in dark tonal frameworks, but not as easily as we can in bright areas.

COLOR

Color is personal. Many photographers can be identified as much by their consistent color palette as by their preferred subject matter. Some eschew it altogether in favor of monochrome; some simply keep their saturation very low, while others prefer intense, bright colors. Scientists have found that where you've lived, what you've seen, and even the language you speak affect your sensitivity to colors.

All successful color photographs have to orchestrate color relationships by choosing which hues, how many, how bright, and how saturated (intense, or far from gray). There are infinite possibilities, although our response to them varies. However, certain principles get everyone's attention.

COLOR CONTRAST: SIMILARITY & DISSIMILARITY

When both hue and luminosity appear very different, we perceive a high degree of contrast. Color and tonal contrast help us separate one thing from another. Contrast of any kind gets our attention.

It's common practice to represent the wavelength of light not on a linear scale, but in a circle known as a color wheel. It's a useful way to clarify color relationships.

COLOR RELATIONSHIPS

The contrast between colors of similar wavelength (hue) typically feels low. They're referred to as analogous colors: e.g., red and orange, green and blue, etc. They are neighbors on the color wheel. A big difference in luminance can make even analogous colors strongly contrasting.

Colors on opposite sides of the color wheel are known as complementaries; they have an inherently high degree of color contrast. A near-complementary is one of the neighbor colors that comprise an exact opposite: red and green or magenta and cyan are near-complementaries. (Red and green are the components of yellow.) Near-complementaries also have a pleasing degree of contrast.

Both of these color studies are classic two-color schemes. The image of the striped wall and hose is built on the analogous colors red and yellow (with a high degree of tonal contrast), while the image of sunlight on the blinds utilizes yellow-orange and blue complementaries.

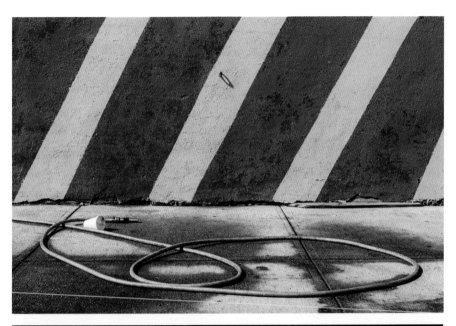

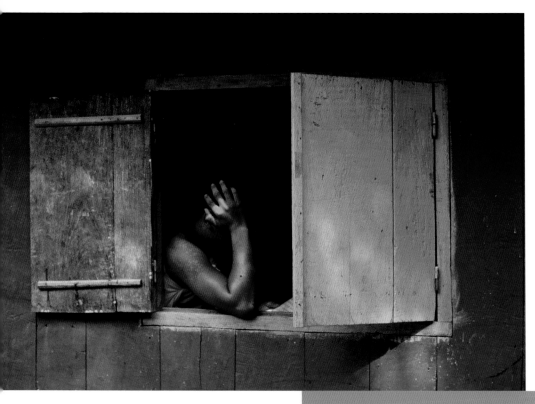

HUES

While the number of colors far exceeds the number of unique words we have to describe them, our feeling about colors that just work together and those that clash is impossible to quantify mathematically. However, what we seem to agree on is that restraining the number of dominant hues in an image helps it feel visually pleasing. There are innumerable successful photos built on two dominant colors. Three-color images very often use a pair of complementaries with a third color that's analogous to one of the complementaries, as

Steve McCurry is justly known for his use of color, which he orchestrates as skillfully as any artist by choosing what to include in his frame. Consistently he makes use of strong complementary colors, often with a third analogous color.

in the example above by one of the greatest masters of color, photojournalist Steve McCurry. The image is dominated by complementaries yellow and blue, with a spot of orange, an analogous color to yellow. Including every color in the rainbow might be necessary in an image of the produce in your local grocer, but can be overwhelming.

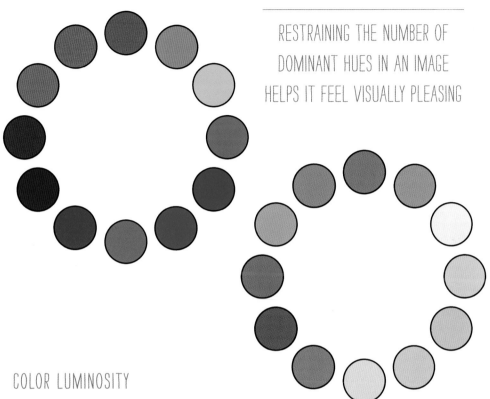

COLOR LUMINOSITY

The three cones in our eyes are not equally sensitive to all colors. This diagram gives you a sense of how luminous various colors appear to the human eye. The brightness of each gray circle illustrates how brightly we perceive each corresponding color circle. You'll notice that the warm colors—yellow, orange, red—have the most apparent luminosity. Warm colors seem to move toward us in the picture plane, while we perceive cool colors—blues and purples—to be less luminous, and thus they tend to recede. The more luminous a color appears, the more reliably it will "pop" out of the frame, even if it only fills a small area.

Photographers are often told "Put a little spot of red in every picture." This technique refers directly to the fact that we perceive warm colors to be more bright then cool ones. The "color spot" guideline is that the size of areas of color can be in inverse proportion to their apparent luminosity. Even small spots of bright colors (yellow, orange, red) will catch the viewer's eye because they seem so luminous, while small spots of less luminous colors (blues, purples) will not emerge quite so clearly without filling more of the frame.

MOTIFS

Our brains are exquisitely attuned to patterns. We recognize repetition, and use it to predict the future in hopes of avoiding negative consequences as well as finding future pleasure. So we are primed to "connect the dots" in images, to recognize related gestures, shapes, colors, etc. We are curious detectives; we love solving puzzles, tracing a theme across items related by their inclusion in the frame.

What does it take to establish a pattern? It turns out that a single repetition creates a reflexive expectation in our brains that we've detected a pattern. We immediately expect that the next occurrence, the third occurrence, will be the same as the first two. We can't help it. If our brains didn't work this way, we probably wouldn't laugh at jokes, or be surprised at much of anything. All forms of art use the principles of establish–repeat–vary to surprise the audience. Even more visual repetition is common in photographs, and provokes an even greater sense of surprise when the pattern is broken.

WE ARE PRIMED TO "CONNECT THE DOTS" IN IMAGES, TO RECOGNIZE RELATED GESTURES, SHAPES, COLORS, ETC.

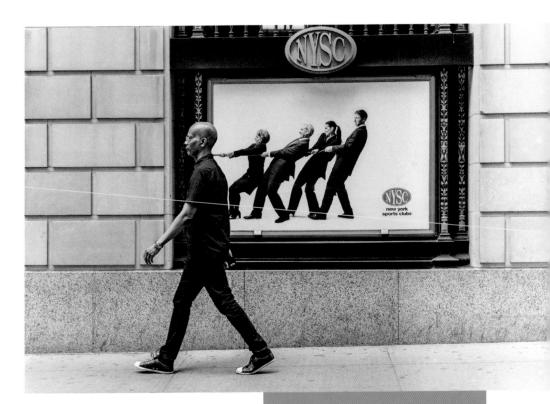

There is something inherently satisfying in the mental act of connecting ideas, recognizing relationships or patterns: in this case, ghostly echoes of methods of ascent and descent. We seem to be wired to reason out cause and effect, to identify relationships and assign meaning to what we experience, regardless of whether it is sensory input or ideas already in our minds.

Stretch

Here, photographer Nipun Nayyar caught a split-second moment where a poster seems to be interacting with a passerby, aided by the consistent color of the clothes.

Helsinki, Finland (Dog Stretching), 1982.

Finnish photographer Pentti Sammallahti manages to be in the right place at the right time to catch a funny echo between a tree and a stretching dog.

OUR BRAINS ARE EXQUISITELY ATTUNED
TO PATTERNS. WE RECOGNIZE REPETITION

Bag, November 2007.

Motifs can also be based on history. Photographer Hendrik Kerstens has created images that reference iconic Dutch seventeenth-century portrait paintings, but with surprise modern twists—a plastic shopping bag, in this case.

SURPRISE & DELAY
EXPLOITING EXPECTATIONS

Once you're familiar with the elements that get the viewer's attention, it's tempting to use them all. But students of art history will notice that images that endure are those that slow down the viewing experience. A lasting image rewards close, prolonged, repeated attention. It gives the viewer the pleasure of finding clues, connecting themes, figuring out the mind of the photographer, even learning something about themselves as the shifting meaning of an image mirrors their own changes.

THE TELLING DETAIL

Our survival-driven brains are so invested in deciding what we're seeing as quickly as possible that even a small delay in mental processing is significant. When unexpected elements are revealed after we've unconsciously concluded what an image means, we get a little surprise, an aha! experience. Deliberately *not* using any of the principles of visual attention outlined in this chapter is a simple way to delay perception and set the viewer up for those surprises.

John Szarkowski, the third curator of photography at New York's Museum of Modern Art and a monumental figure in the struggle to help viewers appreciate photography as an art form, wrote a brief but seminal book called *The Photographer's Eye*. In it, he spoke of five elements to look for in a photograph. Two of them are relevant here: the inescapable boundaries of the photographic frame, and the idea of a telling detail.

In the moments when we first see an image, our eyes scan rapidly. Our brains analyze at an astounding rate, comparing what we're seeing to our mental model of the world. Our experiences, prejudices, proclivities, and expectations create a gut-level, split-second response. We draw conclusions before we even know we've done so.

And then we see something else. Something small. Something quiet in a dark corner of the frame, inconspicuous, devastating. A telling detail is something we don't see right away, but when we do, it changes or completes the meaning of the image. We've been set up.

In the masterful example opposite by Garry Winogrand (a Szarkowski favorite), we notice the fashionably dressed young women immediately. They're sizable, centered, in brilliant backlight. They epitomize youth, beauty, fashion. But this is not the point of the

Los Angeles, 1969. Garry Winogrand.

photo. Any conversation has paused. They are not looking at each other, but to the left, where we finally notice the man slumped in his wheelchair. He is in the shadows, the antithesis of youth, beauty, happiness, or success.

Keep looking, and you'll find explosive details everywhere: the horizon itself is cocked. Something is "off." This is no small town street; this is the corner of Hollywood Boulevard and Vine in Los Angeles, the fame and success of movie stars etched into the very pavement. A young boy is watching this drama play out. One woman reaching for her purse, whether to make a donation or keep it safe, we don't know. The sunlight from behind the women comes not from one point, but from two. It's been reflected off the storefront, a second set of shadows

coming to a point with the first. Two very different realities are colliding.

Even after we know an image's secrets, we experience this delay and surprise every time we look at it. Our ways of looking are so hard-wired into us that it's almost impossible not to see things as we do.

Like a good joke, the punchline depends on the setup. A smart image is keenly attuned to the assumptions of viewers, and exploits their expectations for the very purpose of subverting them.

APPLIED PERCEPTION
MASTERS AT WORK

Photographers don't think any more about lines, ISO, or scale than you think about nouns and verbs. They master the language of their medium so they can tell their stories. Ultimately these same tools form distinctive portraits of the individuals behind the cameras. Here is a brief look at the work of two artists producing photographs for very different purposes.

ELINOR CARUCCI ISRAELI, LIVES IN NEW YORK, B. 1971

Elinor Carucci's subject has always been herself and her family as they've navigated challenges, large and small, familiar to anyone. But few have ever photographed the human condition with such frankness and intimacy. Marriage. Parenthood. A cut. The tears of children over dramas as minor as a haircut, and of adults over those as enormous as betrayal.

Life leaves its marks. Just as we might be getting comfortable with ourselves, it confronts with us with our inability to control not just death, but change itself. Carucci examines it all, omitting no detail, however excruciating. Her frequently nude staging emphasizes our fragility: I was here. I was both beautiful and flawed. I was changed both by life's wonders and terrors. She won't let us forget any of it.

Emmanuelle having her hair cut, 2007.

Adults who are not parents may have long forgotten just how huge the most trivial dramas of their childhoods were. The first day of school. An irrational crush. Getting your hair cut. Carucci brings us into such intimate proximity to the raw emotions of these events in her family that it can be as difficult to look as it is to look away.

I hold Eran's wounded hand, 1998.

The fundamental choice faced by every photographer is simply "What shall I photograph?" What is surprising is how widely people search for something to photograph. A spectacular landscape. A foreign people. Tragic events. Carucci looks no further than the people closest to her, and in their daily struggles, triumphs, and suffering, finds the whole world of universal human experience. She vividly highlights the dramas that most of us simply wouldn't think to photograph—or wouldn't dare.

I WAS HERE. I WAS BOTH BEAUTIFUL AND FLAWED

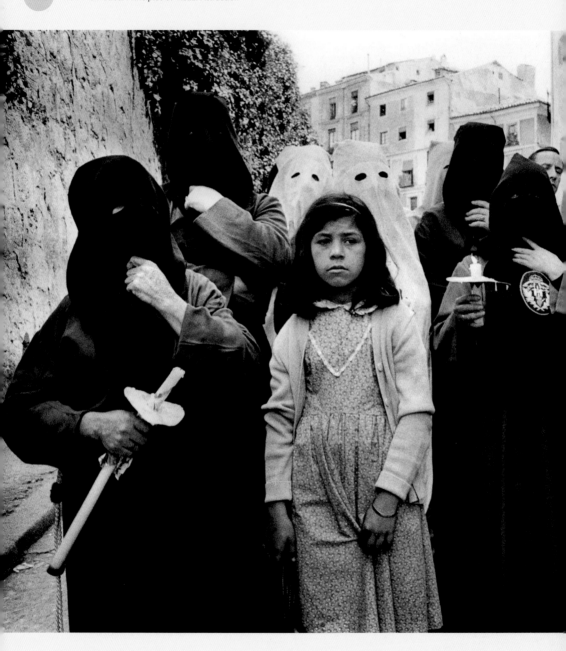

CRISTINA GARCÍA RODERO
SPANISH, B. 1949

Working in documentary style, Rodero's work remains true to photography's roots as an honest document of the world as it is. A searing catalog of the elaborate religious and pagan rituals by which human beings attempt to purify or satisfy themselves, her work is characterized by visceral elements: fire, water, blood, and extreme emotions. This is photography as witness, action-packed frames containing entire worlds. But the moments she chooses also form a very specific portrait of the photographer herself. These images are not advertisements for religion or ritual. They are questions, not answers.

Spain. 1982. Cuenca. The penitent girl.

Children appear prominently in Cristina García Rodero's pictures. They gape. They cry. In their world, magic is not only possible but probable, and indistinguishable from myth. They stare, uncensored, wondering at the extraordinary behavior of the adults around them.

Tetrarch 4.19pm, 23rd January 2008

CHRISTOPHER BUCKLOW BRITISH, B. 1957

In this era of ubiquitous digital cameras, it is not easy to find a way to make images that don't look like anyone else's. Yet Christopher Bucklow has done just that in his "Guest" series using little more than the sun, some aluminum foil, and sheets of light-sensitive photographic paper. No camera, as such, is used.

Successful works of art marry content with a form that seems perfectly suited to the ideas being explored. These ghostly figures are not portraits in the traditional sense, yet both their form and their subject comprise a portrait of their maker and his influences as complex, layered, perhaps unknowable entities.

The process begins with casting subjects according to a simple criterion: they are people who have appeared in his dreams. Shadows of the figures are then traced onto aluminum foil into which tens of thousands of tiny holes are punched, creating multi-aperture portraits of the sun as it's projected onto the photographic paper behind. The haunting and spectral character of the resulting images seems perfectly appropriate given the fact that they begin as dreams.

Bucklow talks about this body of work as a self-portrait, suggesting that people who have qualities that we both admire and despise mirror something within ourselves. His unique photograms are literally a portrait of light by which we are revealed (if not known) to each other. They also allude to the kind of brilliant energy by which all matter was made and became us—a process as mysterious as we are to each other, and perhaps even to ourselves.

3

HOW WE THINK
DECODING PHOTOGRAPHS

THEORY OF MIND

I pointed out earlier that cameras can't record thoughts; they only record light. While that's perfectly true on a mechanical level, one of the miraculous aspects of human beings is their ability to guess what other people are thinking, to understand that their thoughts are different from our own. Psychologists call this ability "theory of mind." We play this game every day, in business, in relationships, to guess how to please (or even displease) other people. We love figuring out "what's really going on," imagining the thoughts of the photographer and the people photographed.

Wilmington, North Carolina, 1950, Elliott Erwitt.

GAZE FOLLOWING

The most subtle body language suggests thought, even when devoid of movement. While still infants, and with astonishing speed, we become experts at detecting when someone is looking not just in a certain direction, but looking attentively *at* something (as opposed to staring into space, focused inward). This is called gaze following.

When we realize that someone is engaged by the sight of something, as with these two men looking at a young woman (left), we follow their eyeline to the object of their attention, and imagine their thoughts. We might even imagine that the angel looking down at them is passing judgement on the men who might have come to Central Park to see her, this famous statue, but whose attention has wandered. We follow the looks of anything remotely human, like the mannequin above that seems to be staring reproachfully at the woman who might have just made off with her arms and her dress in Elliott Erwitt's clever example.

Our mind reading is also the basis of most miscommunication. Our guesses are often wrong because we tend to assume that others think like we do. Viewing photographs and learning that there are very different ways of looking at the world can enrich our lives by expanding our perspective.

MIRRORING: ART AS SELF-PORTRAIT

Regardless of whether we imagine what a photographer was thinking, one of the greatest functions of art is to reveal both makers and viewers to themselves. You may be doubtful that a photographer could be surprised by their own images, but one of the main points of this book is that most of what goes on in our own brains is inaccessible to consciousness.

Photographs can reveal profoundly formative experiences that have affected a photographer in ways that they might underestimate or even be unaware of. Artist James Fee initially attributed his persistently dark, brooding images to disenchantment with the broken promises of the American dream. After tracing some of his outlook to the childhood discovery of his father's experiences in a grim, protracted battle on the tiny Pacific island of Peleliu, experiences that haunted his father until his suicide in 1972, James later commented that the unconscious mind is a deep thing, and that what we see as children is remembered forever.

Given how the mind protects us from painful experiences, burying memories in our unconscious, it's perhaps not surprising that artists cannot always figure out what it is they're looking for by consciously thinking about it. The pictures themselves point the way.

MIRRORING THE VIEWER

When viewers look, they interpret. They construct meaning. Their conclusions are filtered through their own unconscious beliefs. The fact that the same photo will be interpreted many different ways testifies to the role of the viewer. How you decipher Hans Palmboom's image of a reluctant greyhound doubtless depends on how you feel about the autonomy of dogs and our relationship with them.

Employing a degree of ambiguity and raising provocative questions rather than providing singular answers give viewers room to draw their own conclusions, and mirror their own minds back to themselves. An enduring image transcends its maker.

CEREBRATION IS THE ENEMY OF ORIGINALITY IN ART

MARTIN RITT

*Night Freighter,
Baja, New Mexico*

James Fee's distinctively dark, often fractured images are emblematic of a common experience for artists. Highly personal in their depiction of American icons in shambles, they guided him on a journey deep into his own childhood impressions received through his father and internalized unconsciously, only to emerge decades later through his work like a map of his most formative experiences.

Girl pulling on the leash of a greyhound racing dog at Gulf Greyhound Racing Park, Texas.

A hallmark of effective images is that they suggest a story without offering conclusive explanations. Leaving a degree of narrative and emotional ambiguity invites viewers to actively construct a unique interpretation that combines their own experiences with the content of the image, and that mirrors and changes with them as individuals.

OMISSION & IMAGINATION
INSIDE & OUTSIDE THE FRAME

While exact estimates vary, there are only two fiction writers whose book sales are measured in the billions: Agatha Christie and William Shakespeare. While Shakespeare's genius makes him required reading for most students of English, what is it about Christie's detective stories that so many have loved?

In a nutshell, we like mysteries. We like piecing together clues, guessing what's really going on, and being surprised. Any writer will tell you that being asked to think, to analyze, and to predict is much more rewarding for readers than simply spoon-feeding them everything.

Yet many photographers clobber their viewers with images in which everything is represented with maximum clarity, sharpness, contrast, color, and attention. Nothing is left to the imagination. The ways in which digital darkroom software have made post-exposure manipulation possible have doubtless contributed to the temptation to "perfect" images by turning all knobs to 10, as it were.

One of the most surprising and profound ways that images create a rewarding viewing experience is by omission. When something is hinted at but shown only vaguely or not at all, the viewer's imagination is triggered. And no tool in a photographer's arsenal of tricks is as powerful.

It's astonishing how even familiar subjects can be rendered surprising simply by omitting key elements, as I tried to do in this image of a horse's neck.

Hungarian master André Kertész intrigues us by withholding a clear view of his human subject, something the survival-driven, curious part of us would very much like to identify.

By obscuring the identity or even the gender of the balcony onlooker, the viewer is forced to lean in, to imagine that which the photo refuses to show. Encouraging the active imagination of the viewer rewards close and prolonged scrutiny of the image, and creates a more enduring viewing experience.

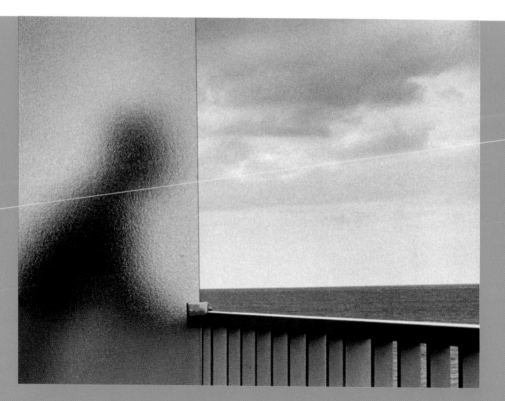

Balcony, Martinique, January 1972.

Who is behind the frosted glass, and what are they thinking? Can we even be certain of gender? What are they looking at? Kertész's masterpiece raises far more questions than answers, and is a singular illustration of how the use of restraint provokes us to think and makes us look longer than at images that leave nothing to the imagination.

CONSTRUCTING A 3D WORLD FROM 2D IMAGES

On our planet, light happens to come from somewhere above us most of the time, from a single source, casting shadows that are strong relative to the density of the atmosphere, or strongly diffused and soft on cloudy days. We have no experience living on planets that have multiple stars close enough to cast shadows. Our sense of what's "normal" is just a product of where we happen to find ourselves. It's what's familiar.

Horror movies exploit the way that the unfamiliar is discomfiting by lighting faces from below to scare us. If we lived on a planet where light came from below, they'd be using light from above to achieve the same effect.

Highlights and shadows help our brains figure out the contours of even unfamiliar objects.

I made this portrait of my student Misha to demonstrate the classic approach to lighting a face: two sources of light at ~45º angles alternate with shadows to underscore the three dimensional shape, while also providing a flattering thinning effect.

I exploited the soft light of a cloudy day to render this portrait of my student Meng Meng in a flat, illustrative, high-contrast 2D style that tends to widen our impression of the shape of her face. The light is almost directionless; only the soft shadows under her nose, lips, and chin hint at the source.

Shipping container and formica table

James Simpson has a strong preference for simple, large shapes and an overwhelming emphasis on flatness. By placing each area of the image on equal footing, he balances complimentary colors, textures, and patterns, inviting us to compare them.

When a bright surface turns dark, we decode that the surface is turning away from the light. Even when looking at a flat, two-dimensional photograph, we can still figure out what surfaces are actually flat and which are undulating.

Photographs can alternate highlights and shadows to underscore three-dimensionality, as I did in this portrait of Misha (left), or they can minimize the tonal range to underscore flatness, as I did using frontal soft light in this portrait of Mengmeng (far left).

Artist James Simpson reveals the influence of his background in collage through his emphasis on two dimensionality, using tremendous depth of field and soft light to flatten and compress space.

Outdoors, depth cues help convey space and scale. Distant objects take on the color and tone of the atmosphere. This is most obvious on days when there is humidity, dust, or pollution.

THE EXPERTS SPEAK
JULIE GRAHAME, CURATOR

Curator Julie Grahame is known for her wit and passion as much as her unfailingly stellar taste. A fierce proponent of strong narrative and conceptual content as well as beautiful presentation, her website aCurator.com is a gold mine of under-appreciated contemporary photography.

Market Town: Tilney1: the Pornography of Despair and the Ideas of Reference, 2012.

J A Mortram turned his own anxiety at taking care of his disabled mother into a ten-year project, spending countless hours with people on the fringes of British society. With deep empathy, humanity, and a style rooted in a tradition of socially conscious documentary photography, his project "Small Town Inertia" brings us into intimate proximity to people whose suffering is often compounded by misjudgment and isolation.

From the series *The Three*.

Documentary photographer Isadora Kosofsky fulfills the highest criteria of any documentary project: she shows us the most intimate and personal moments in the lives of her subjects—in this case, a love triangle between three people in their 80s and 90s—while simultaneously revealing universal struggles for love, understanding, and companionship.

"I never felt like it was my job to educate the public about anything. I think people who are interested in learning and understanding more about images will choose to do that. I'm sitting here thinking about people like Richard Prince or, for example, the series by Sandro Miller, where he's used John Malkovich to re-create some of the world's most famous photographs. I don't understand taste, I don't understand what causes people to buy things, and I've given up caring to try.

"I only want to publish great work. I think as a curator it's my role to not publish lots of stuff. Everything needs to be strong, and I have to be jumping up and down every time I publish something, which I am. I think it's like night and day, great work vs. OK work.

YOU HAVE TO HAVE SOME EXPERIENCE IN LIFE TO HAVE SOMETHING RELEVANT TO SAY

David at home, early 2013 (from the series Market Town: David: The Long Goodbye).

J A Mortram's photography blog about marginalized people in his small town of Dereham, U.K. and the abuse and scorn that they experience on an everyday basis has affected far more than fans of documentary photography. His patient, persistent efforts have effected real social change.

"I'm looking for photography that says something. I prefer something to have a message, be that documentary, personal, self-reflective, cathartic. One of my favorite people probably in the world right now is a photographer [James A. Mortram] who has never strayed further than two miles from home and makes work with people who live in the margins of society. The photographer himself has nothing, not a penny to his name, and what he's interested in is helping other people who he perceives as having even less than him. And his work is absolutely incredible. His images stand out above almost everything that I see on an ongoing basis. And without exception, people can see how relevant and important and well-executed his photography and his stories are.

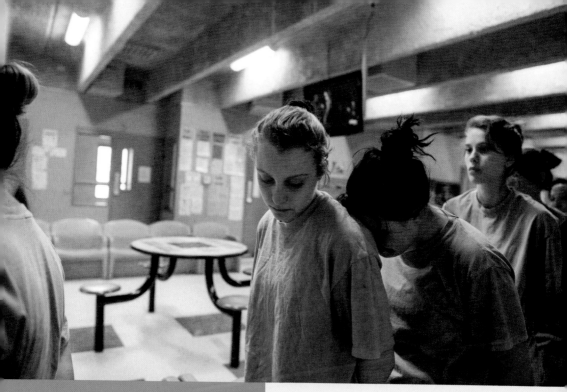

From the series *Alysia*.

Isadora Kosofsky is keenly interested in people looking for love under unusual pressures. This image is from a series that follows a young woman from New Mexico from the time she was incarcerated at age 16 through her subsequent marriage and motherhood.

"I've published 18 year olds; I've published 70 year olds, professionals, amateurs. I don't care who they are. I want the images to tell a story. I rarely publish disparate images from a photographer; there needs to be a tale to them. Features are cohesive but the images can also stand alone, and the clean, elegant platform of a curator supports this. It doesn't alienate the viewer. I really either want to kick someone in the balls or grab their heart out of their chest. But it doesn't all have to have a

serious message, not by any stretch of the imagination. I like to take a breather and go on a road trip sometimes in the magazine as well.

"I see so much boring! And I see boring published, and see boring being elevated, and it pisses me off. There are a lot of assumptions about things like Instagram and other platforms that people like myself even have the time to sit and go 'Woo, yeah. That's interesting.' I couldn't care less.

"I still feel like only one in a few hundred photographers is actually really, really, really great. How that comes to them, I don't know. You have to have some experience in life to have something relevant to say."

THE SHOCK OF THE FAMILIAR

BEAUTY & ATTENTION

Beautiful subjects—flowers, sunsets, kittens, models—are some of the most photographed images in the canon. They are the tireless fodder of social media posts, greeting cards, motivational posters, and coffee mugs. We love them, and why shouldn't we? They were not intended to hang on museum walls; their function is simple. There is nothing revelatory about them. They simply affirm what we already agree on, although I'm afraid the dogs-vs.-cats argument may never be resolved.

TIME & ATTENTION

Despite the steady flow of time, our perception of its passage is elastic. This is caused by the way that new experiences trigger the brain to pay closer attention, to record a high level of detail, to learn. Years that are dense with new experiences seem to have lasted longer because we have rich, detailed memories about them, rather than a blur of unremarkable, familiar experiences.

Given the demands of adulthood, perhaps it's not surprising that the rich delight we took as children to really explore and linger over every new experience gives way to a more utilitarian way of living. As we get older, we tend to pay less attention to the growing list of experiences we've already had. Yet we walk around assuming we're still seeing as vividly, when we actually see less and less.

This assumption, coupled with a lack of close perception, sets us up to be most surprised not by beauty or by novelties, both of which we give more attention, but to the most ordinary things that are around us every day. We simply overlook them. Why pay special attention to what we already think we know?

Here's an utterly ordinary "thing" that intrigued me: a lone door in the side of a seemingly endless wall adjoining an abandoned parking lot. I have no idea what is behind that door, or why it looks like the shadow of a fence is burned into it. It is a strange boundary, and has led me to look for others like it. But I enjoy the questions it raises more than I like telling you what you already know: that sunsets are beautiful, for example.

It is not easy to take a surprising picture of a flower. In a sense, it is already perfect, as well as having been exhaustively examined, painted, and photographed by countless others. If you really want to shock your viewer, give them a fresh look at an object that they walk past every day. The chances are they've never really experienced it.

THE TRUE MYSTERY OF THE WORLD IS THE VISIBLE, NOT THE INVISIBLE

OSCAR WILDE

When you start paying attention to little details, they start showing up everywhere. You wonder how you could have missed them. Life presents us with infinite layers of complexity and leads us to fascinating stories hiding behind the ordinary. When we start to notice which of those particularly resonate with us, they start to reconnect us with our most personal and enduring themes.

In this image from Detroit, I was probably seeing the city's difficult past reflected in the crumbling pavement and the ominous light, but also a sense that, like the ghost of what looked like a picket fence on the door, there was always hope for change lurking at the periphery—or on the other side of the door.

IT IS CLASSIC, COMPLETELY SATISFYING—A PEPPER—BUT MORE THAN A PEPPER: ABSTRACT, IN THAT IT IS COMPLETELY OUTSIDE SUBJECT MATTER

EDWARD WESTON ON HIS PEPPER #30

VANTAGE POINT

While photographers learn to carefully compose elements in the frame, where they position their cameras can convey as much about their idea as their choice of content.

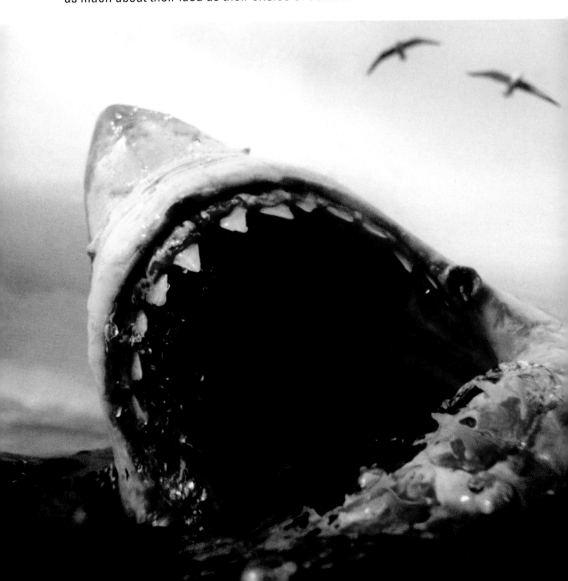

Pay attention, and you'll notice that the vast majority of photographs are made from where the photographer happened to be standing at the time. Thus, exploring unusual vantage points is one of the easiest ways to defy expectations and grab the attention of the viewer.

It's surprising just how ingrained our expectations are with regard to vantage point. We unconsciously assume that an image will show us the comforting eye-level perspective we're used to seeing. Confronted with atypical vantage points, the viewer's attention is heightened, and they're engaged in actively trying to understand what they're seeing.

The best examples provide the "aha!" experience when the viewer, like someone waking up in a strange room, finally realizes where they are. The human brain reflexively seeks to make sense of what it sees, and this process of moving from disorientation to clarity provides a sense of reward that endures even on repeated viewings.

Eyelevel view of Great White Shark, (Carchardon Carcharias), **Stephen Frink.**

I can think of few examples of vantage point as powerful as Stephen Frink's astonishing shot of a great white shark breeching the surface. Positioning his camera at water level in such close proximity to this terrifying animal gives us an experience that few of us will ever have - even if we wanted to!

Cape Kennedy, Florida, 1969.

Master street photographer Garry Winogrand put himself at an historical event, the 1969 launch of the Apollo 11 rocket from Cape Kennedy, Florida (above), but unlike all of the other photographers in his image, not because he wanted to photograph the rocket taking off. His photos convey his consistent interest in human behavior, in the unusual woman who might mirror his own unconventional curiosity as she turns her camera away from the spectacle towards an unknown point of interest.

Vantage point does more than change the composition. It conveys a photographer's idea and personality, and hints at their feelings about the subject. It also affects how we feel about the subject. Todd Heisler's portrait of serial killer David Berkowitz (right) conveys anything but a desire for intimacy; the camera keeps its distance.

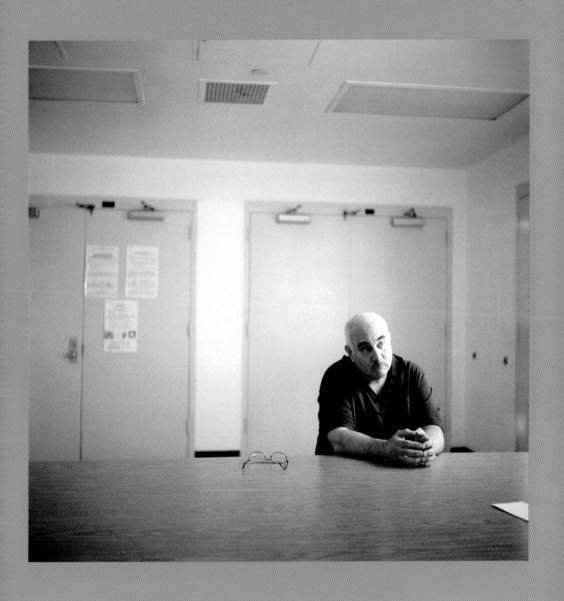

IMPLIED RELATIONSHIPS

Photographers invite us to actively seek the meaning of images by highlighting elements and implying a connection between them—even if it only exists in the mind of the viewer. If you look back at my image of the battered traffic cones on page 59, you'll see I took a deadpan view of the cones, inviting the viewer to compare their varying success at surviving the wear and tear they'd experienced.

That day, I was walking around New York with my friend, painter Lorrie McClanahan. As I was shooting this photo, I was aware that she'd run ahead of me. Just as I clicked and turned away, she leapt forward and snapped this photo. You'll recognize some of the same cones I

photographed—but she was after something else. She'd been watching me, had seen the cones, and in those few seconds, she anticipated a photograph that could only be constructed if she was in exactly the right place, if her depth of field rendered everything

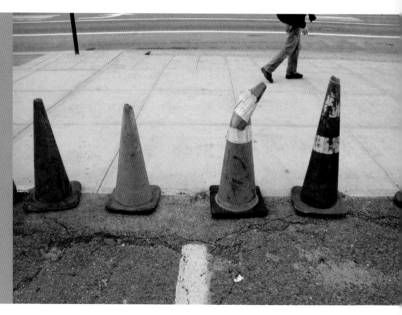

Lorrie McClanahan constructed this image in her mind long before it happened, positioned herself precisely and captured it with split-second timing. She has a strong preference for images that require the viewer to think—in this case, to supply an element of cause and effect or intention that in fact only exists in our anthropomorphic mental model of the world.

Effective images leave clues and ask us to use our own imaginative creativity to connect the dots, to complete the story or meaning hinted at in the image. Here, I tried to show how youth and beauty are celebrated in a way that aging is not.

equally sharp, and most importantly, if she snapped the shutter exactly when it seemed as if the cone was bending to follow me or pull me back, as if it would miss me once I was gone.

I was dumbfounded when I saw how precisely she not only executed this image, but how expertly she pre-visualized it in her head. It's even more humbling to see her execute equally complex, subtle images through her entire body of work.

VISCERAL QUALITIES

Although the brain devotes the majority of its resources to processing visual input, and far less to the other four senses, we are not merely seeing creatures. While we lack the extra sensitivity to odors and sounds that other animals have, what we touch, smell, hear, and taste are all essential parts of our human experience.

Although our brains are compartmentalized to a certain extent in the way they process sensory input, externally stimulating one sense triggers related sensations in our minds. What we see in photographs can trigger powerful sensory associations that greatly broaden the impact of an image beyond the visual. Enduring images exploit this fact.

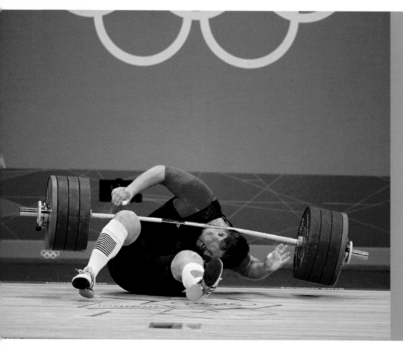

Weightlifting: 2012 Summer Olympics: German Matthias Steiner on ground as weights fall on his neck after failing to lift on second attempt to snatch - 196kg during Men's +105kg Group A at ExCeL London.

While we don't have direct access to anyone else's mind, theory of mind describes our ability to imagine the mental experiences of other people as different from our own. Visceral images might be said to provoke a kind of theory of body, an empathy for and imagination of what it feels like to be someone in the photo at the moment it was captured.

The next time you see people watching something happening on the street (or in a theater), turn away from the spectacle and watch how the faces of the viewers mirror what they're watching (a trick Eisenstadt frequently exploited, with unforgettable results). The way that photographs reduce physical experience from five senses to one only seems to provoke us to fill in what's missing: the sounds of shrieking children, for example.

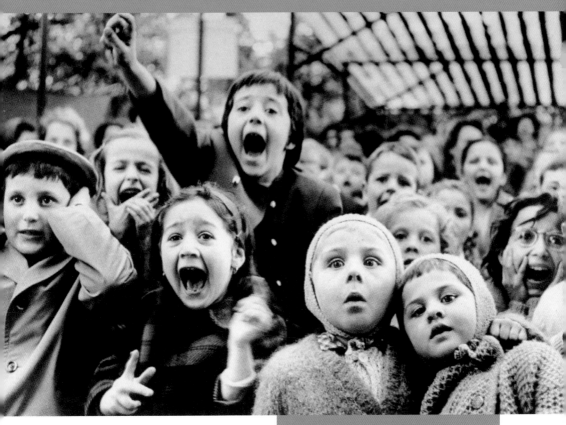

Children with a varied range of expressions watching story of St. George and the dragon at the puppet theater in the Tuileries, 1963

I defy you to look at the unfortunate Olympic weightlifter in Simon Bruty's perfectly timed image (left) without wincing.

Although Alfred Eisenstadt's timeless image of French children omits the puppet show that they are watching, from their extreme range of emotions and gestures, you can imagine the shrieks and shouts of the children.

Wind, weather, pungent smells, tactile sensations, sounds—a photograph that triggers any of our other senses heightens its impact on us.

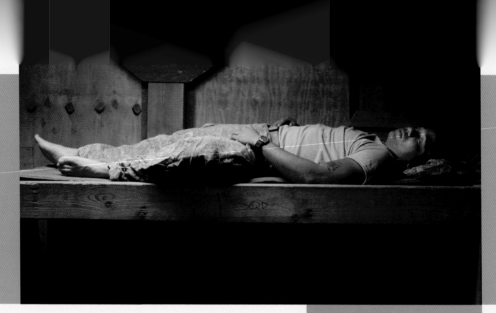

Korengal Valley, Kunar Province, Afghanistan. Lizama sleeping, 2008.

THE EXPERTS SPEAK

MARC PRÜST, PHOTO CONSULTANT & CURATOR

"I'm interested in nonfictional photography. That fits between photojournalism and documentary. It's still based in reality, but the story is very much the perspective of the photographer. That's not the truth with a capital 'T,' because I don't think that's actually possible with photography."

What is it to "read" a photo?

"When you look at a photograph, you get very easily distracted by its beauty. To read a photograph is to look for clues that the photographer actually wants to say something. Those can be direct references to what the photograph shows, to other pieces of art, movies or paintings, even other photographs. That goes beyond the mere aesthetic value of an image."

Some people are self-conscious in how they pursue a concept. I also know successful people who insist that thinking will get in your way. Does that depend on the person?

"If you don't know why you take the picture, you don't know how to take the picture. The better prepared you are before going out in the field, the better you're able to improvise and go with the flow. In soccer, they say that the best teams don't get lucky; they force their luck."

What do you mean when you describe photography as a "visual language?"

"Photography communicates ideas, concepts, and feelings, [but] it needs context. I don't think it can communicate facts as such. But it can make those facts touch you emotionally."

*Korengal Valley, Afghanistan.
Grenade Bandolier, 2007.*

While Tim Hetherington's portrait of a sleeping soldier in Afghanistan and his very personalized bullets could be viewed as a straightforward document, it also exists in the context of art history, human conflict, and themes of war, revenge, and duty. The pool of light in the dark plywood room, the hard, bare surface, and the prone figure of the soldier can be traced back to innumerable paintings of the dead body of Christ and the theme of sacrifice.

Are photos more open to interpretation than text?

"The viewer will assume that everything was there on purpose. In many cases, it just happened to be there and not a lot of thought went into the creation of the photograph. There is more room for interpretation in photography than in text. It's up to the photographer to make that open medium as closed as possible. That's when communication starts."

Why do people like certain images?

"Ninety percent of the photos being taken today are to share experience. You're liking the experience, not the photograph. Then there are photographs that you take because of memory: I take pictures of my kids, or you get married or whatever.

"Then there are the photographs that are taken purely as a document: the city council taking pictures of all the houses taller than 20 meters or whatever. Then there are the photographs that people take not because they're interested in the photograph, but because they enjoy the process of taking pictures. It's much more photography as therapy.

"Then there's photography that's about message: a person tries to identify the right kind of image in order to communicate an idea or opinion about the world."

Has photographic practice changed?

It used to be very difficult to take 10,000 pictures. Now, any 13 year old will have done it just because they have a mobile phone. It's easier to take pictures than it is to read or write. [but] The skill to tell a visual story is the same as being able to write a novel."

What it is it that makes an image rewarding to look at over and over again?

"A lot of pictures are very beautiful, but they are illustration. They hang nicely over the couch, but at the end of the day, they are only of something and not about something. The images that stick with me are of one thing but about something else."

TIME
CONSTRUCTING NARRATIVES

A photograph has to tell a story in a single frame. It compresses a finite period of time into a single image, stopping the stream of time. But what happened before and after the exposure are also key to the success of a photograph. The difference is that these can only be suggested to the mind of the viewer.

TRANSCENDING THE TIME FRAME OF THE IMAGE

Time seems intangible, not directly photographable. It is not a "thing" that we can hold, yet it is a fundamental force. Although the single frame might seem like a limitation compared to time-based media like video, music, or performance art, all mediums have to find a way to turn what might be liabilities into assets.

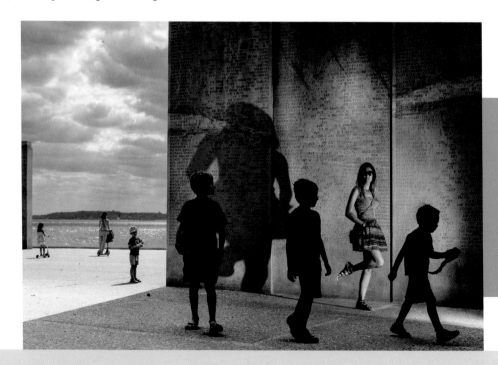

One Last Wish, A terminally ill woman sees her favorite Rembrandt painting one last time. Ambulance Wish Foundation.

A photograph is a kind of shorthand. It is not a novel, a play, or a movie. Yet it's surprising how it can transcend the time frame in which it was made. A particularly telling moment implies a past and future, while leaving the details to the imagination.

The image above is a favorite example of mine. The museum setting isn't hard to understand (it happens to be the Rijksmuseum in Amsterdam), but why are the only viewers of this famous Rembrandt painting a medical crew and someone confined to her bed? You do not need to know the whole story to guess that it took some trouble to get this particular woman here, and that the event carries no small significance.

In cases like this, captions become important. Some but not all photos are self-explanatory. You might guess, but the full explanation is that the unnamed woman in the bed was photographed by a volunteer working for the Ambulance Wish Foundation, a charitable organization in the Netherlands that fulfills the last wishes of terminally ill patients. This woman's request was to see this painting one last time, so the volunteers arranged for her to visit the exhibition after hours. She passed away from ALS (a motor neuron disease) not long afterwards. The significance of this moment in time for someone who knows that their days are limited is part of this image's power.

Time was very much on my mind when I made this image. Something struck me about the parallels between the three silhouetted children, lined up as if in birth order, and the Asian family at left; the staging at the site of the World War II memorial in New York City; the odd stance of the woman that reminded me of marching soldiers, but whom I also imagined as the mother of young people sent off to fight a war from which so many did not return, some of whose names line the monuments around them.

Prague, August 1968. Warsaw Pact troops invasion.

OUTSIDE THE TIME FRAME

In 1968, 30-year-old Josef Koudelka was in the wrong place at the right time when he photographed the Soviet Union's invasion of Czechoslovakia. He smuggled out amazing images of tanks rolling through the streets, violence, citizens, and soldiers, remaining anonymous for 16 years to avoid reprisals. Yet his most famous image from that time remains this one, his own wristwatch a quiet, ominous countdown to the approaching Soviets, and a testament to the power of our own imaginations.

TIME, TECHNOLOGY, & CULTURE

Not only are photographs testaments to the passage of time, they are inextricably linked with change by the form they inhabit via technological innovations. These family snapshots from 1965 and 1970—and my memories of these times—are forever linked to color palettes produced by film stocks that are long gone, along with all of their glorious chemical imperfections. Ironically, the very inaccuracies that photographers used to complain about, especially with regard to color film, have become desirable again in a backlash against the predictable, homogeneous accuracy of today's digital cameras.

MY MEMORIES OF THESE TIMES ARE FOREVER LINKED TO COLOR PALETTES PRODUCED BY FILM STOCKS THAT ARE LONG GONE, ALONG WITH ALL OF THEIR GLORIOUS CHEMICAL IMPERFECTIONS

SHAPE AS CHARACTER

We project human qualities onto statues, pets, inanimate objects, and even abstract shapes. We anthropomorphize. We see character even in simple shapes.

Shapes have emotional and narrative qualities. They can be soft, squishy, sinister, funny—or at least that's how the creative, associative human mind sees them. While shapes are just shapes, human beings assign meaning, character, and intention—human qualities—even to the most innocuous forms. Image-makers exploit the way viewers assign meaning to provoke imagination and involvement.

You may see the big shadow on the wall as an elephant, a monster, or just a mysterious shadow (of a flag, as it so happens). The point is, viewers don't just see what's in a photo; they see what's in themselves. We project our own feelings, history, and personality onto the image. We construct stories and imagine future outcomes that mirror ourselves.

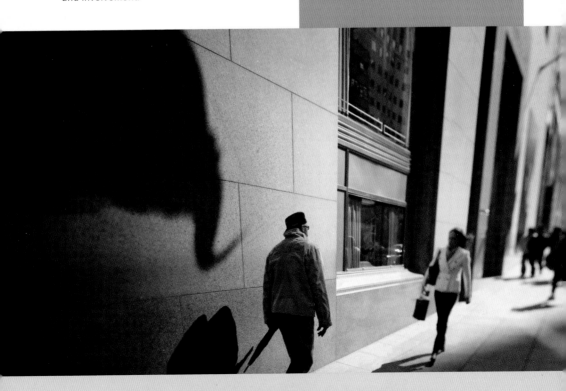

Hauts-de-Seine, France. Parc de Sceaux, 1987.

The nomadic Josef Koudelka's famous image of the Parc de Sceaux is riddled with triangles: the ears of the dog, the angle of its left rear leg and the way it is leaning forward in mid-stride, the echo of its ears in the silhouetted trees in the distance, and the single note of counterpoint in the looped tail. The vast landscape and the animal who dominates it is echoed by shapes that could be brothers, but which remain distant and disconnected. It has a graphic power that defies simple explanations.

There's an old saying among photojournalists: "*f*/8 and be there." It refers to two strategies: always keep your camera settings ready, and make sure you're in the right place at the right time. The rest might be chalked up to practice, developing the ability to recognize an iconic image in a split second, and a bit of luck. For a great example, look on the Magnum Photos website, where you'll see another frame from almost the same moment and the same vantage point. The same dog is there, but compared to this masterpiece of form, it is quite ordinary.

Photojournalist Damon Winter's use of a heavy foreground silhouette in his dramatic portrait of Barack Obama beautifully echoes the weight of expectations he carried with him into office—or at least that is one possible reading of this photograph. The dark shape at the top of the frame in and of itself means nothing. It is featureless, if presumably part of a building. But to fill nearly half of a frame with blackness is a bold choice, one which, in the hands of a professional of Winter's calibre, we can rest assured must have been deliberate.

Democratic candidate Senator Barack Obama arrives at Dallas Love Field Airport en route to a town hall meeting at Newman Smith High School in Carrollton, Texas, on March 3, 2008

A good photo is not effective because it provides singular, definitive answers that leave no room for interpretation—quite the opposite. The visual language capitalizes on the fact that human beings assign narrative qualities to everything. We don't merely see; we interpret. We make up stories—provided the image leaves room for us to do so.

Shapes can suggest events, histories that transcend the time span of the photo. The extreme force that it must have taken to bend this metal gate raises the question of who or what might have done it, and whether the red truck lurking on the periphery might be a suspect.

CONTEXT & JUXTAPOSITION
THE FLUIDITY OF MEANING

There is a famous study of human perception that every filmmaking student is taught: Soviet filmmaker Lev Kuleshov conducted a simple experiment in image juxtaposition. He created three silent sequences: a shot of a bowl of soup, a child in a coffin, and a reclining woman, all juxtaposed with a close-up of an actor. When he tested these sequences with viewers, they confidently reported that the actor was feeling hungry, sad, and lusty with respect to each sequence. His revelation was that meaning depends on context—the images of the actor were exactly the same shot, and in it, the actor was simply being neutral. The power of juxtaposing multiple images is not limited to cinematic montage. What a single photographic frame includes and excludes, what elements are juxtaposed and underscored through any of the principles of visual attention we outlined in Chapter 2, and even the context in which a photograph was made have a profound effect on how viewers will interpret the image.

While Americans are annually inundated with reminders of Christmas (and to shop accordingly), the stark rendition of a crookedly stenciled "Merry Christmas" on a dilapidated wooden structure conveys neither cheer nor prosperity. But it's the juxtaposition of this element with the equally run-down house with its crooked "for sale" sign in matching green that gives this image its melancholy impact.

I'd been admiring Haystack Rock off the coast of Oregon when I spotted a surfer headed towards the water. I was fortunate to already have a long 200mm lens on the camera, and arranged the elements to tell the story. The repeated visual motif of the gap between his arms and body and the right side of the rock help connect the dots.

One of the fundamental decisions all photographers have to make is whether or not to include a specific context for their subject. To photograph something out of context strips it of telling clues: environment, place, profession, etc.

Martin Schoeller's perfectly lit studio portrait of a homeless woman provokes a very different response to the more typical but also sympathetic context in Bruce Gilden's portrait of a homeless man sleeping on the streets of Tokyo. Is one more truthful than the other? Does the omission of context make a photo more or less truthful, or just affect our feelings about the subject?

Critics may never agree on the presence of truth in photography, but they can agree that all of these photographic choices affect our perceptions in ways that we are typically not aware of.

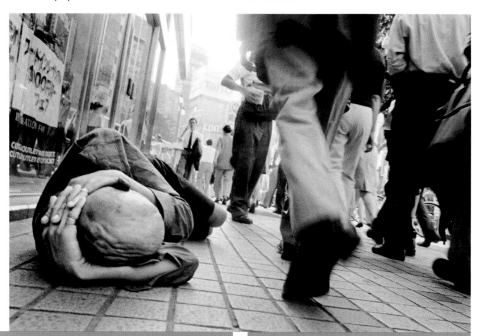

Betty Jo Rhodes.

Martin Schoeller's approach (left) is to treat all of his subjects the same in terms of technique, whether they are world leaders, glamorous celebrities, or people living on the streets. We're given the opportunity to look them straight in the eye up close and in great detail, brightly lit, stripped of any accoutrements or circumstances that commonly predispose us to pre-judge them.

Tokyo. 1999. Homeless man sleeps in the streets while commuters pass by.

This photo is consistent with Gilden's preference for working in very intimate proximity to his subjects with a fairly wide-angle lens. The fact that the passersby seems as oblivious to him and his camera as they are to the unfortunate man on the street only underscores the poignancy of the image.

LIGHT AS SIGNIFIER

All mediums of expression have a form. Photographs exist within a frame, a boundary; they are two dimensional. A photographer's palette, use of lenses and focus, choice of subject—every choice in the medium—comprises an artist's unique form. Form exists to give shape to, and underscore, content.

Light has character. It is part of the silent language of photography. It does more than illuminate, direct attention, or create mood. Light is the great punctuation of the image. Photographs can be awash in light or suffused with darkness. They can convey the gloom of night or the glare of a summer day. But it's the contextualized, selective use of light that really exercises a potent, inexplicable effect on us.

While light itself may not contain inherent meaning, it is a kind of enunciation that heightens what it illuminates. Conversely, shadows and silhouettes convey tension. They can be sinister, moody, or just visually dramatic, as in Christopher Tyree's dark portrait, shown opposite.

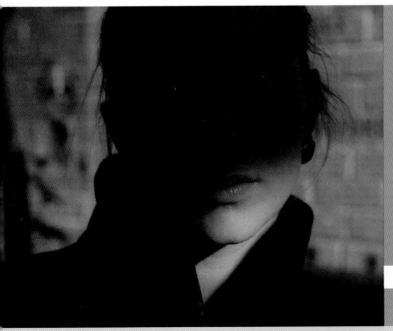

A beam of light falling on someone surrounded by shadows heightens not just visual impact, but the seeming importance of that moment. A shadow across someone's face makes us lean in to discern what they're thinking. We may project a darker state of mind onto someone in the shadows than in the light. Photographs employ light and shadows to orchestrate our feelings about the subject in a way that bypasses rational thought, the way films use sound design and score.

From the series *Citizen*.

COLOR AS MEANING

I've hinted many times that enduring photographs reward a viewer who is invited to actively participate in the interpretation of the image, to bring his or her own experiences and even prejudices to their individual reading. One of the reasons that photography is able to maintain such fluidity of meaning even as it remains inherently representational is that many of its components are entirely subjective.

While color may not have intrinsic, universal meaning, it is inextricably linked to your cultural background, technology, geography, clothes, even the way location and weather affect the light by which you see. Through cold New York City winters, I was always struck by how rarely I saw people wearing anything other than black, gray, and brown. The first time I visited West Africa, I was overwhelmed by the bright colors and patterns of the women's clothes. Meanwhile, the pale green of sagebrush and the red dusty earth will always remind me of Wyoming's vast plains and dry weather.

Color connects us to place and time. It's an ongoing conversation with history, cultural shifts, with births and deaths. Right now, for example, an enormous shift is taking place that will affect the entire planet: all of the deep red-orange sodium vapor streetlights are slowly being replaced by low-power, low-heat LEDs of a much cooler color. Eventually, photographs made at night will reference a time in history that has come and gone as surely as gas lamp streetlights disappeared before color photography could capture it.

Ivory Coast. Hotel Sofitel Abdijan, 2004.

Red is used in very different ways in these images, despite appearing in the outfits of both key figures. In Stuart Franklin's photo on the left, red pulls the eye through this image. The way that it's pervasively pale or faded in the car, the architecture, and the sign only highlights the boldness of it in the man's shirt; whatever the past, he presages a brighter future.

Here the cheerful, vivid colors on the girl's costume reference a specific pop icon that places it firmly within cultural history, and makes her stand out against the near-colorlessness of the surroundings just as distinctively as her choice itself to appear as a favorite character.

THE EXPERTS SPEAK

ELISABETH BIONDI, CURATOR

"I don't believe there's truth in photography, ever, ever, ever in any way. I think there are pictures that can be authentic or not authentic, or can contradict the truth, but maybe there's never truth in anything. That's why I'm interested in people who are on that cusp of expressing their opinions and photographing what they see. If you click for 20 minutes, and the photographer pulls out one portrait, is that the truth about the person?

"I remember hearing when [Richard Avedon] photographed the Duke and Duchess of Windsor. They're like this: [she makes a stiff face]. So the story goes that he had asked his assistant to come in and say 'Something terrible happened: the dog was run over!' And that's when he took the picture. So there's something in his photographs—a question mark. There was something startling or unusual in his pictures that he managed to get. There was something that got your attention, even if you didn't know why it was. I think he brought out something that was authentic, even if he used means that weren't 100% truthful.

"I think that a photograph functions more like a poem. It's sort of inclusive. It's not like 'pinpoint this.' It has a function that's broader than the specific. Or if it's the specific, the specific also has to be the universal. In German you have *Bildsprache*. *Bild* is picture and *Sprache* is speech, so picture-speech.

From the ongoing series *Experimental Relationship*, begun 2007.

Pixy Yijun Liao found that her provocative images of her and her boyfriend produced a surprising backlash of criticism, particularly from those who questioned how she could treat her partner as she apparently has for the sake of the photos. This image, which she captions "Relationships work best when each partner knows their proper place," is part of a series that reverses the usual power dynamics in romantic relationships, a particularly provocative position for someone who comes from a country known for valuing traditional gender roles.

Look at this picture. It's showing post-war Germany fleeing from the east to the west. The photographer (Hilmar Pabel) instinctively took this picture because he knew what was going on. I think it's an incredible photograph of what it's like to be a refugee.

The picture is outside us but there is some dialog going on inside between our head and our eyes. When you look at it, it's an outward thing that explains where you stand, and what it is about you. It's a conversation. A conversation is again a word-picture.

"It's different if you show them in a magazine, or even newspapers are already slightly different—or if you see them on the wall, or if you click on the computer, and you go 'da-da-da-da,' then the sequence has to be good. I will always look at what the idea behind this is. How in images and pictures is a story told best, and how is the idea behind it best displayed.

"I like people who think about photography by and large. Maybe because I'm German. [*Laughs.*] What's instinctive is that you have done something for a long time, you've thought about it for a long time, and you don't have to think about it anymore. You see it, and you know it's there. Most good photographers are instinctive, even if they've thought about it.

"I think I'm really old-fashioned in this: I think pictures are visual, and they should give some pleasure. Some of them are more thought-out, and are more intellectual than instinctive.

"Because everyone can [make photos], artists have to do something more—something that's beyond the representational. Photography is free from the duty of reporting strictly what things look like. It doesn't mean it has to stop, but it's free from that obligation."

CONCLUSIONS

CONCLUSIONS

EVERYONE IMPROVES WITH PRACTICE.
THERE ARE NO SHORTCUTS. IT'S THAT SIMPLE

The power of a great image often defies analysis. Its total effect is more than just the sum of its parts. A great image never employs every technique described here, but uses a subset of them in such a way that each element strengthens the whole. Neither the weaknesses nor the strengths of an image draw undue attention to themselves; the image as a whole just works.

Image-making is as complex as perception itself, and most photographs are made too quickly for direct consciousness over the process, so when everything comes together, it can be as surprising for the photographer as for the viewer. Doing that consistently requires more than luck; it takes mastery.

An important note about this for those who aspire to it: the confusing part about mastery is that the expert does things with such speed and precision that it looks easy. It looks like they're

not thinking, not looking, that they just have some kind of magical talent. Masters themselves are sometimes guilty of feeding our appetite for myth-making, claiming that their work is effortless and done without thinking.

In my experience, it's not that they're not employing the kinds of principles outlined in this book. They practiced and internalized the craft in their own way just like everyone else—even if they deny any awareness of them. The longer you practice, the shorter the gap between inspiration and your ability to react and capture what you pre-visualized. At some point, the expert is able to react so quickly and with such control that it looks like magic.

It isn't. Everyone improves with practice. There are no shortcuts. It's that simple. Enjoy your own path to mastery and a deeper appreciation of images.

GOING FURTHER

This book covers a lot of ground in a short space. If any of these topics are of interest to you, here are some resources that were inspiring and helpful to me through the many years that this book percolated until it ended up on paper.

Arnheim, Rudolf: *Art and Visual Perception: A Psychology of the Creative Eye*

Bang, Molly: *How Pictures Work*

Bright, Susan: *Art Photography Now*

Brommer, Gerald F.: *Illustrated Elements of Art and Principles of Design*

Chabris, Christopher/Simons, Daniel: *The Invisible Gorilla: And Other Ways Our Intuitions Deceive Us*

Clarke, Graham: *The Photograph* (Oxford History of Art)

Dondis, Donis A.: *A Primer of Visual Literacy*

Eagleman, David: *Incognito: The Secret Lives of the Brain*

Eagleman, David: *The Brain* (PBS television series)

Edwards, Betty: *The New Drawing on the Right Side of the Brain*

Heiferman, Marvin: *Photography Changes Everything*

Hoffman, Donald D.: *Visual Intelligence: How We Create What We See*

Ings, Simon: *A Natural History of Seeing: The Art and Science of Vision*

Jeffrey, Ian: *How to Read a Photograph: Lessons from Master Photographers*

Livingstone, Margaret: *Vision and Art: The Biology of Seeing*

Mann, Sally: *Hold Still: A Memoir with Photographs*

Mlodinow, Leonard: *Subliminal: How Your Unconscious Mind Rules Your Behavior*

Morris, Errol: *Believing Is Seeing: Observations on the Mysteries of Photography*

Noë, Alva: *Action In Perception*

Noë, Alva: *Out of Our Heads: Why You Are Not Your Brain, and Other Lessons from the Biology of Consciousness*

Noë, Alva, editor: *Is the Visual World A Grand Illusion?*

Ramachandran, V.S.: *The Tell-Tale Brain: A Neuroscientist's Quest for What Makes Us Human*

Ritchin, Fred: *Bending the Frame: Photojournalism, Documentary, and the Citizen*

Schwartz, M.D., Jeffrey M./Begley, Sharon: *The Mind and the Brain: Neuroplasticity and the Power of Mental Force*

Szarkowski, John: *The Photographer's Eye*

Zakia, Richard D.: *Perception and Imaging: Photography—A Way of Seeing*

ACKNOWLEDGMENTS

Two experiences probably did more to provoke me into writing this book than anything else. The first was a childhood spent watching images magically appear days or even weeks after they were shot in the trays of my father's and grandfather's darkrooms, learning the entire process of photography from film choice to framing a hand-made print. I was fortunate enough to grow up with a constant flow of meticulously crafted pictures rotating through the walls of our family homes. That ongoing testament both to the passage of the years and the power of the image was formative and enduring, even though I knew nothing about the critical reading of photographs, or about making them for anyone else.

Many decades later, I found myself in the strange and wonderful position of being asked to create a college photography department literally from scratch. It was a rare opportunity to organize all of my long but haphazard experience into something cohesive. Being the kind of person who likes nothing better than to dive into waters way over my head, I dove.

In the years that I spent as chair of the photography department at New York Film Academy, I had to hire and manage staff, write curriculum, and teach hundreds upon hundreds of students whose needs and prior experiences were as varied as the countries from which they came. It was a wonderful, terrifying experience in which I doubtless learned more than any of my students and staff because I had to.

To the enormously talented staff of teachers I am most grateful, not only for their patience, but also for all that you taught me. In particular, David Mager, who ended up being my co-chair, who was more than just the ideal partner— bold, passionate, expert, an inveterate problem solver, energetic, and an incredible human being—he was my dear friend and an irreplaceable colleague.

To all of my students, I thank you for your questions, for answering them gave me the impetus to dig ever deeper. Thank you for your enthusiasm, talent, and good will.

Finally, I could not have written this book without the patience, support, suggestions, and expert editing of my first and best reader, my beloved wife Ragnhild.

PICTURE CREDITS

The publisher would like to thank the following
photographers for permission to use their images.

7 The Museum of Fine Arts, Boston. Public domain or CC BY 2.0 via Wikimedia Commons; 9 Metropolitan Museum of Art, New York. Gift of Mary W Tweed, 1929, CC0 1.0; 16a Keith Binns/iStock; 22b Pier Paolo Cito/AP; 24a Brothers Good/Shutterstock; 24b alexsl/iStock; 40 Michael Crouser, from the book *Los Toros*; 46 Blanton Museum of Art, The University of Texas at Austin, Gift of Mari and James A Michener, 1991; photo Rick Hall © Richard Anuszkiewicz/DACS, London/VAGA, NY 2018; 47 Josse Christophel/Alamy Stock Photo; 48 Photo courtesy Di Wu and Andreas Velten/MIT Media Lab. Visit http://web.media.mit.edu/~raskar/trillionfps/); 50 Los Angeles County Museum of Art. The Marjorie and Leonard Vernon Collection, gift of The Annenberg Foundation, acquired from Carol Vernon and Robert Turbin. Digital Image: Museum Associates/LACMA/Art Resource NY/Scala, Florence © Paul Caponigro; 52 Slava Veder/AP; 53 Public domain, via Wikimedia Commons; 62 Jim Brandenburg/National Geographic Creative; 64 Ragnhild Kjetland; 65 © Estate Bernd & Hilla Becher, represented by Max Becher, courtesy Die Photographische Sammlung/SK Stiftung Kultur - Bernd und Hilla Becher Archive, Cologne; 67 Bjarte Bjørkum; 68 © James Casebere, courtesy Lisson Gallery; 69 © Martin Parr/Magnum Photos; 70 Edward Weston © Center for Creative Photography, The University of Arizona Foundation/DACS 2018; 76b © David Burnett/Contact/nb pictures; 77 Granger Historical Archive/TopFoto; 78 Photo by Major Clarence L Benjamin/US Army; 79 Kevin Lamarque/Reuters; 82 © Elliott Erwitt/Magnum Photos; 83 © Matthew Stuart/Magnum Photos; 89 © Raymond Meeks via Webber Represents; 90 Trang Tran; 93 Photography by George DeWolfe; 96 © Steve McCurry/Magnum Photos; 99 © Nipun Nayyar, nipunnayyar.com @nipumnayyar; 100 Pentti Sammallahti; 101 Hendrik Kerstens Photography, courtesy Flatland Gallery Amsterdam; 103 © The Estate of Garry Winogrand, courtesy Fraenkel Gallery, San Francisco; 104, 105 Elinor Carucci, courtesy of Edwynn Houk Gallery; 106 © Cristina Garcia Rodero/Magnum Photos; 108, 109 Chris Bucklow, courtesy Danziger Gallery, New York; 113 © Elliott Erwitt/Magnum Photos; 115a Courtesy of the Estate of James Fee and Craig Krull Gallery, Santa Monica; 115b Hans Palmboom; 117 © 2018 Estate of André Kertész/Higher Pictures; 119 James McLin Simpson; 120, 122 J A Mortram; 121, 123 Isadora Kosofsky; 126 James D Watt/Stephen Frink Collection/Alamy Stock Photo; 128 © The Estate of Garry Winogrand, courtesy Fraenkel Gallery, San Francisco; 129 Todd Heisler/New York Times/Redux/eyevine; 130 Lorrie McClanahan; 132 Simon Bruty/Sports Illustrated/Getty Images; 133 Alfred Eisenstaedt/Pix Inc/Time & Life Pictures/Getty Images; 134, 135 © Tim Hetherington; 137 Courtesy Stichting Ambulance Wens, photo Roel Foppen; 138, 141 © Josef Koudelka/Magnum Photos; 142 Damon Winter/The New York Times/Redux/eyevine; 144 Lorrie McClanahan; 146 Martin Schoeller/AUGUST Image; 147 © Bruce Gilden/Magnum Photos; 149 Christopher Tyree; 150 © Stuart Franklin/Magnum Photos; 152 Pixy Liao; 153 Hilmar Pabel/bpk Bildagentur. All other images courtesy and © Brian Dilg.

INDEX